DRAWING

foundation course

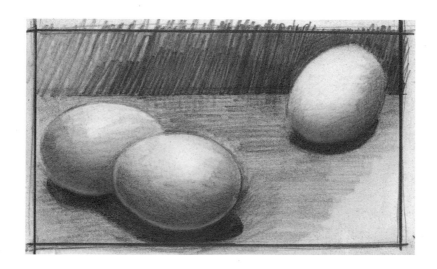

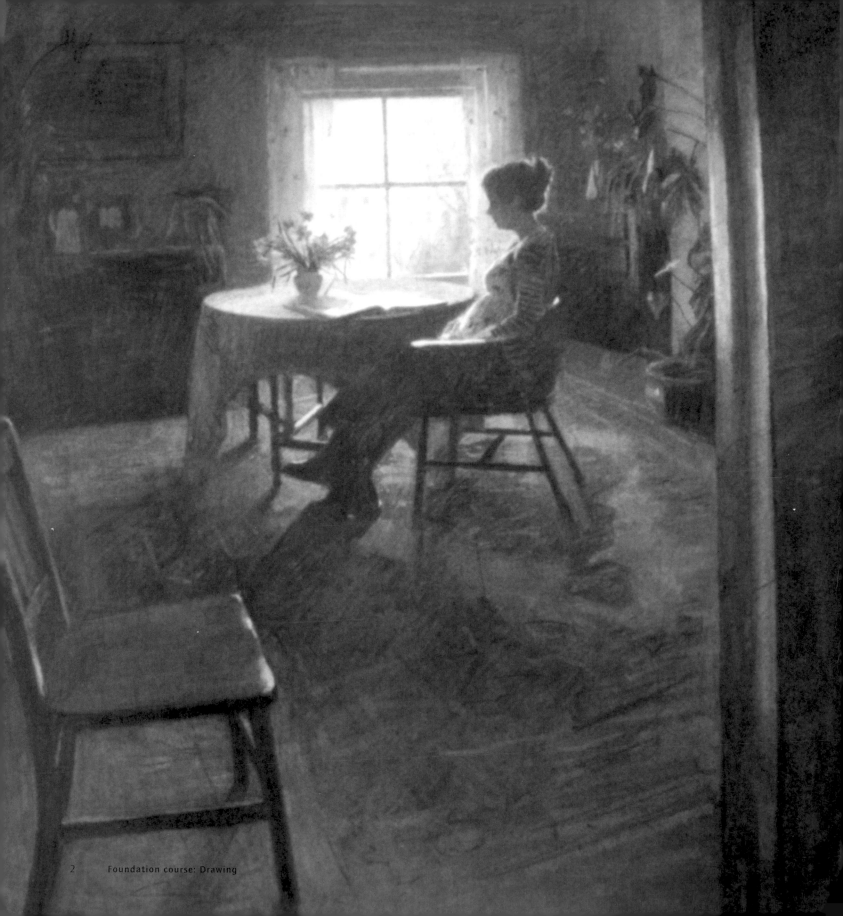

DRAWING

foundation course

Paul Thomas and Anita Taylor

Bounty
Books

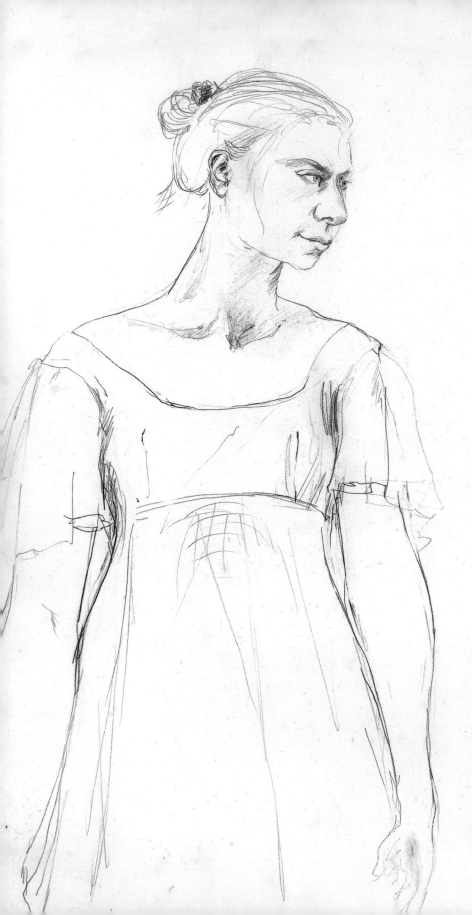

This edition published in 2016 by Bounty Books, a division of Octopus
Publishing Group Ltd. Carmelite House, 50 Victoria Embankment,
London EC4Y 0DZ, www.octopusbooks.co.uk

An Hachette UK Company
www.hachette.co.uk

First published in Great Britain in 2003 by Cassell Illustrated,
a division of Octopus Publishing Group Ltd.

Editorial Direction by Roger Sears
Designed by Isobel Gillan
Edited by Michael Leitch

A CIP catalogue record for this book is available from the British Library.

ISBN: 978-0-75373-106-2

Printed in China

Contents

Introduction

This book aims to show the principles, procedures and technical skills of drawing, introducing the key concepts and skills of drawing practice, working from observation and exploring expression and subjectivity.

Through a structured set of exercises, designed to develop an increasing awareness of the different aspects of drawing, the authors describe a practical approach and place this in the context of why artists draw. The book embraces a full range of methods from observational drawing to the use of digital media as a drawing tool. There is an extensive section on methods and materials used to make drawings. The aim is to be user-friendly, and to relate equally to those who are interested in learning how to draw as beginners, and those who are enrolled on art and design courses and desire a comprehensive introduction to drawing that encompasses traditional and contemporary approaches to drawing today.

The authors have been teaching drawing to undergraduate and postgraduate students in the UK since 1978 and 1987 respectively. During this time they have devised a number of courses, which encompass a range of drawing practices and inform students about the historical precedents for drawing, and its uses and purposes. Additionally, they have worked to develop an arena for the recognition and promotion of contemporary drawing practice in its widest sense, through the establishment of The Jerwood Drawing Prize, the largest and most significant annual open drawing exhibition in the UK.

The notion of drawing as the signifier of talent and skill within Fine Art has been the subject of a challenging and contentious debate within recent years in education. The commercial galleries have never promoted drawing as a significant activity, which has produced two problems. Artists' drawings have become couched in mystery, while the commercial return on the sales of drawings has become too low to match the high rental and leasehold costs of the central-city locations favoured by the largest galleries.

Artists have also been complicit in the mystification of the making process, collaborating with markets and the media which place a high value on the 'immaculate conception' of art works, which means that intermediate stages in the conception process are hardly ever seen, only the finished pieces. Art schools also challenged the value of traditional methods of drawing, and many Life Rooms were closed in the 1960s for philosophical reasons and later for economic reasons. Technical revolution and the idea of all-pervading movements in art leads invariably to claims such as 'painting is dead', 'drawing is dead', and 'wet-

Anita Taylor, *Seeing Something Else* (detail) (1993), 76 x 56 cm charcoal on paper.

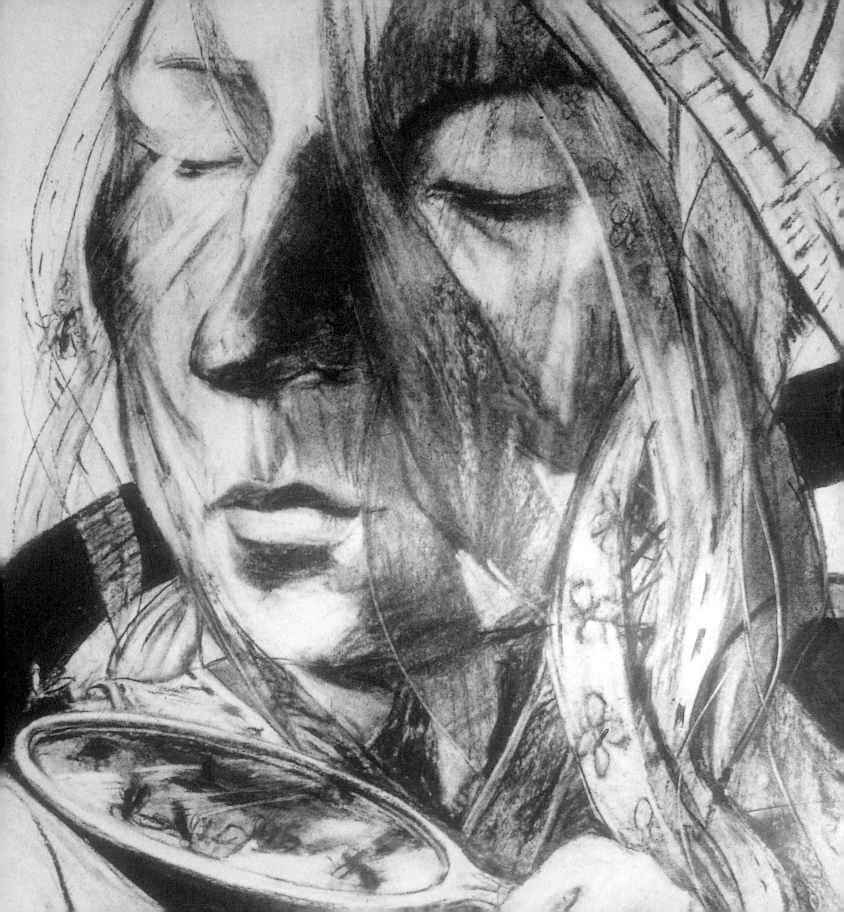

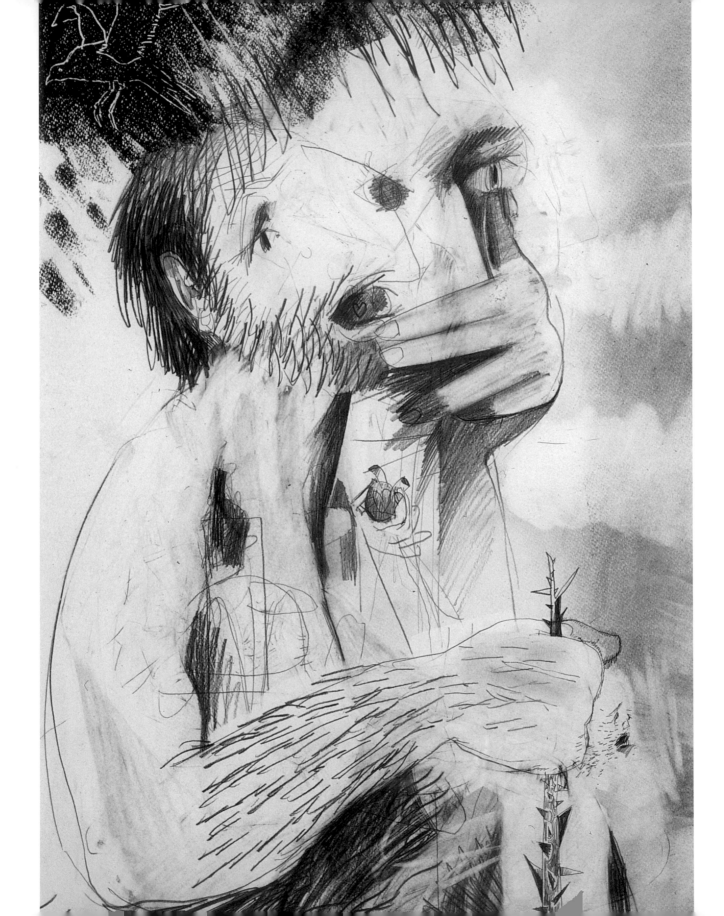

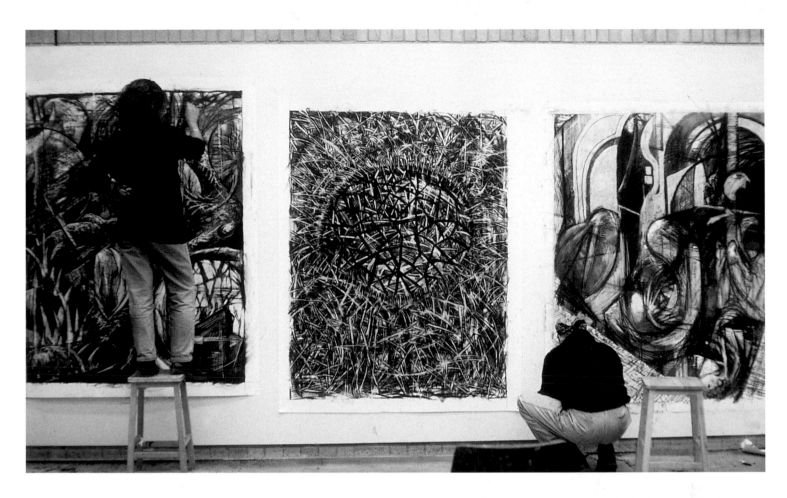

ABOVE: *Students working on the Subjective Drawing course at Cheltenham School of Art.*

OPPOSITE: Paul Thomas, *Odysseus Meets Achilles* (detail) (2003), pencil and chalk on paper

photography is dead'. This negation of existing means by the champions of new processes and methods leads to a false view of what really happens in the studios of artists across the globe.

All means of generating drawing are valid, as long as the conceptual and philosophical meanings are understood – what is important is that the notion of drawing is never purely technical. The creation of an introductory manual to drawing is for these reasons far more complex than that of a process-based manual, as the process itself is inherently bound to the concept that is being expressed, hence the continual questions and debate about what constitutes drawing, what is it for and what are its inherent values.

Throughout the book, you will find a range of examples of different ways of working and how different artists work. These images and ideas have been selected to give clear information about the ways in which materials may be selected to make drawings, and also the kind of work that may be defined as 'drawing'.

THE **HISTORY** AND **PURPOSES** OF **DRAWING**

'Drawing is the art of being able to leave an accurate record of the experience of what one isn't, of what one doesn't know. If one of the purposes of life is to know oneself, then a great deal of time is spent investigating things one already knows. So a great drawing is either confirming beautifully what is commonplace, or probing authoritatively the unknown.'

Brett Whiteley, *Tangiers notebook*, 1967

What is drawing?

The term 'drawing' encompasses a number of meanings. The word suggests both the physical act of making marks on a surface, and, like the Old English word *dragan*, from which it derives, of 'pulling' or 'dragging' an object. This notion of dragging is significant to our idea of drawing.

Most drawing materials are pulled or dragged across a surface, using implements such as a brush, nib, pencil or charcoal to leave behind an imprint or trace of the material. The surface of the grounds or supports for drawing are essentially rough or coarse to some degree, so that the surface acts as a file to the material applied to it, wearing away the graphite, metal, charcoal, pastel or crayon as it moves across the surface. Other meanings of the verb 'to draw' - to extract, to attract - as well as yet others meaning to make manifest, to represent, formulate or perceive, and to form a line between two points, all add to the idea of a physical activity which enables us to make our ideas visible.

What is drawing for?

Writing and drawing are similar in their origins and the development of writing is closely linked to the ideas of drawing. The markings on clay tablets offer some of our earliest records of images and text, running hand in hand. Pictorial ciphers, signs and symbols are readily interchanged, and combinations of these images and hieroglyphs used to communicate ideas, stories, messages and facts.

The hieroglyphs of Ancient Egyptian society are available for historians to read and decipher. There is a clear logic within these pictorial representations that spell out clear narratives. It is easy to see how map-making and factual diagrams could explain complex conceptual problems with ease and economy. Some of these more esoteric communications were literally diagrams for spiritual survival, a far cry perhaps from the more hedonistic excesses of butterfly tattoos on a girl's buttocks in our own culture – or is it? Our need to

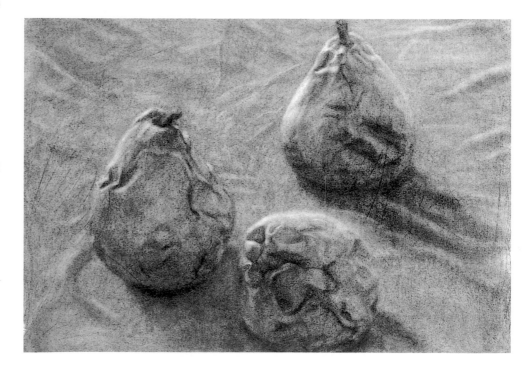

James Rowley, *Three Pears* (1999), charcoal on paper, 56 x 76 cm *This drawing shows exemplary use of tonal judgment. The artist defines the form and volume of the pears, investigating the way light crosses the surface of the skins of the pears and the surface they stand on. The pears gradually wrinkle with age and become synonymous with the wrinkled nature of the fabric or paper on which they sit.*

understand the world through visual means is more abundant than ever.

The range of applications is enormous. Think of operating theatres where limbs are marked with dotted lines and arrows to indicate what is planned; of road-markings and road signs which define for us the rules and regulations of driving; street-finders and Ordnance Survey maps which indicate the route and nature of journeys; Underground maps; lines which tell us how to open packets; lines which define a football pitch; marks or signs to tell us which way up to store something; signs which warn of poison; the graphic language of advertising; logos; safety guides in aircraft; cartoons in the newspaper; coats of arms ... The list goes on and on. All these images share a common starting point. They do not require verbal or written translation. They transcend the barriers of different international languages, and enhance communication in an increasingly international world.

There are distinct ways in which drawing can function. It can help us to understand our complex world through signs and symbols, by mapping and labelling our experience. It can also enable us to discover through seeing – either through our own experience of seeing and observing or through the shared experience of looking at another's drawn record of an experience. It can have a transitory or temporal relationship with the world, or provide a record of lasting permanence.

Who is drawing for?

Drawing is for everyone. It is a universal activity. We all sketch diagrammatic maps to give directions, we all read maps, we all understand the plan on the Underground – all are pictorial and, essentially, drawn. We can all sketch where we want the furniture, the route to the local bar, the notation of landmarks. This is drawing at its most functional everyday level. It is also used to express how building materials may be put together, rooms located

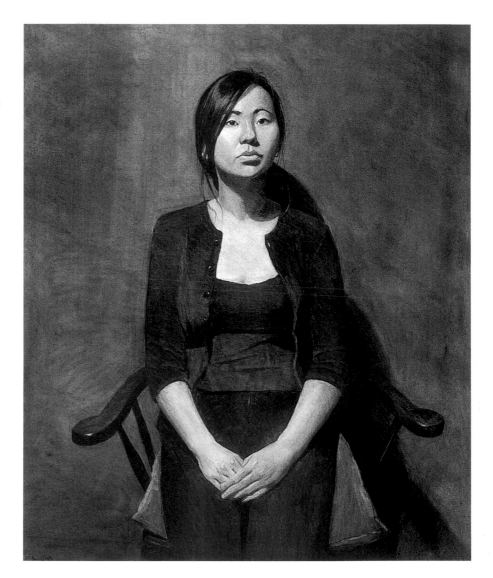

Kim Williams, *Portrait* (2003), charcoal on paper, 122 x 91 cm *This portrait is made by working in charcoal on a mid-tone ground. Darks are added and lights taken away with an eraser or rag. The drawing is made over a period of time during which the light and position of the model change slightly, and the artist has to manipulate the materials to describe a single suspended moment in time.*

together, for architecture and interior design. It is used to schematise the plans for vehicle design, for dress design, furniture design, motifs, textiles and fabric, film storyboards, etc. Drawing is thus used to convey potential, as well as actuality.

Drawing is an innate and impulsive act for everyone at some time in their lives, and enables communication at speed and through the recognition of shared thought processes. However, the privileged position of verbal and written language in Western education has limited people's understanding and recognition of the value of visual language, and drawing in particular, until recently. The idea that visual language essentially becomes a more sophisticated version of our first efforts at drawing as young children, has made many people feel inhibited about their own visual finesse. Most people lack a substantial intermediate education in visual language, and are reluctant to express their lack of facility through drawing, in the same way that shy people are reluctant to show their intellectual limitations through conversation. At the same time, most people lack access to the creative processes of artists, and see only finished or fully realised drawings. This lack of access has mystified the activity of drawing generally.

Drawing for some has become a covert activity. There is an interesting trend in drawing, which involves ideas of defacement, of

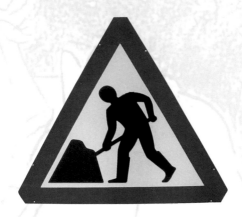

Roadworks sign *This drawing indicates to us that roadworks are taking place. We all read this sign succinctly, without recourse to the written word, indicating the speed with which we assimilate meaning and image. However, it can also be read as a man opening an umbrella!*

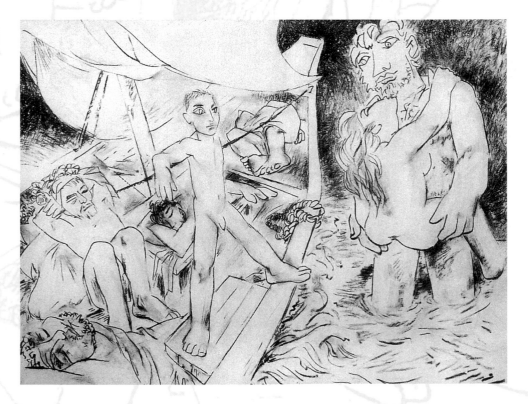

Peter de Francia, *Fables* (1994), charcoal on paper, 46 x 58 cm *'Fables' is a collective title for a series of drawings, which explore the idea of fables and myths which chronicle human behaviour and endeavour.*

negating, and the wilful imposition of a human touch on areas of perceived inhuman presence, as demonstrated by graffiti on trains. Featureless façades of concrete and symbols of state power are often corrupted by an individual asserting freedom of expression. This is perhaps an inevitable consequence of our frustration at finding our natural inclination towards creative mark-making inhibited by authority. In a more positive light, drawing essentially provides a natural, intimate and intuitive way to see our thoughts and to communicate them to others. It can be a simple or complex statement, of value to everyone. Find a surface, and materials, have a think, and then draw 'a balloon' around your think.

Can anyone draw?

Yes, anyone can draw. As children we delight in making marks, scratches on surfaces, being sick … In numerous ways we make our mark in the world. Those with felt-pens and crayons can make drawings of mummies, daddies, houses, pets, teachers, friends – a wealth of autobiographical references. While very young children seem to have few inhibitions about drawing, it is remarkable how quickly, across all cultures, this spontaneous act becomes inhibited and peer pressure leads people to declare that they 'just cannot draw'.

What do they mean? In many cases, they are expressing their fear of others being able to draw a clearer, 'better' view of the world. Identifiable standards or benchmarks come into play, and a notion of naturalistic depiction begins to control individual creativity. Much 20th-century art has tried to reform its relationship with children's inventiveness and spontaneity. This circular process led the great 20th-century draughtsman, Picasso, to declare that he had spent his whole life learning to draw like a child. So, can anyone draw? Yes. However, the question that should be asked is: what constitutes a good drawing?

Paul Ryan, *Concentrate* (2000), ink on tissue, 83 x 109 cm *This drawing seems like a fast gestural response to a set of buildings with a perimeter of some kind. It was started with a very small pencil drawing made in the artist's sketchbook, drawn just after visiting a concentration camp in Poland. In this small drawing there seemed to be so much concentrated into so little; enough to demand closer inspection. Each pencil mark was taken and recreated many times larger, using patterns of dots and dashes in black ink.*

Children's drawings

The apparently innocent child's drawing, shown here, demonstrates certain principles. The figure is subject to gravity, as is the ball; the grass is long enough to hide the footballer's feet, and the ball, with its clearly marked panels and decorative patterning, echoes the player's top, forming a joyful triangle with the sun setting in the sky.

The goal is presented as a hook-shape that contains the ball. If one thinks of a naturalistic depiction, then this hook-shape would be reversed. The ball would have to pass the post and go into the area behind. This was not, apparently, the child's main concern. In this picture, the idea of containing the ball within a frame allows the child to make an inventive set of associations, linking this part of the drawing to the sun, which is also contained in a similar right-angled configuration. The visual link is made with great simplicity and economy of means.

A child's imagination reflects their sense of a world of mysteries to be faced. The ceaseless discovery of things and ideas, and the idea of making pictures to understand them, characterises the drawings of children. It may be interesting to note that most children's drawings contain self-portraits, which over time nearly always follow the same chronological progression. They begin with a spherical shape, which has two sticks protruding from it but no digits on the end. Later on, hands appear, and so does a house which begins to act as a surrogate for the self. One could also speculate that the sun acts as a surrogate for the father and a tree for the mother. If this seems a wild

claim, ask a child to make a drawing containing these three elements. Sit back and ponder the result.

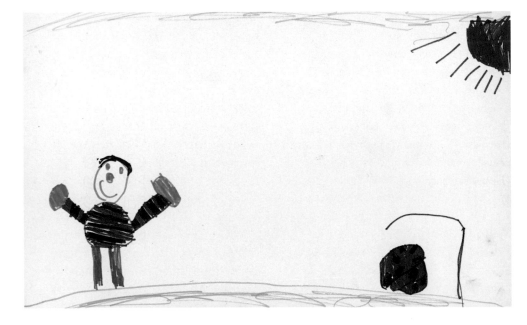

Cave drawing

Some of the earliest examples of drawing can be found in the caves of Spain and France. They include the famous bison drawings at Altamira, and many smaller caves, some only recently discovered. The images are made with carbon and ferric oxides and represent images of animals and people; the significant occupiers of the worlds in which the images were made.

This image of a hand appears to have been made by spraying blown blood over a hand pressed to the wall of the cave, to form a silhouette. There are over fifty of these hands as well as images of animals in this cave at Puente Viesgo. The sheer affirmation of the presence of humans is clear. Each hand is not an imprint, but was defined, revealed or drawn by the process described. Each one leaves a trace behind, which we understand to be important.

Seeing this hand, the same size as ours, and knowing the context in which it was found, makes us reflect on the longevity of the human race, and the imprint an individual may leave on their environment. We become acutely aware of our mortality as we regard these images made thousands of years ago, and simultaneously experience the immediacy of the making process, and through this the actuality of the person who made the image. The static quality of the image of the hand seems like an affirmation of presence, almost a salutation. Another drawing of animals seems designed to convey the energy of the subject. Speculation about the purpose of such images persists, and includes the possibility of shamanistic associations: the notion of persuading good or evil spirits. What is certain

is that the images conjure up or capture the spirit of the animals as drawings, and distil the essential characteristics of the subject.

Recently, the artist and writer John Berger delivered a lecture about cave painting in an Underground station, to give his contemporary audience a contemporary cave in which to imagine what they could see - to make out the images and project their thoughts onto the darkened surface of the walls, cocooned in the earth, as in a cave. Like these ancient artists, we all imagine and see in semi-darkness, freed of the pressures of visibility, and able to explore the relationship between the present experience and the world retained in our minds. As Berger explained, the images made by the inhabitants of the Cro-Magnon caves in Chauvet, France, 'were hidden in the dark so that what they embodied would outlast everything visible, and promise, perhaps, survival' (John Berger, *The Guardian*, 12 February 2002).

These images, spread through the caves, give a sense of space. Although they do not follow the conventions of Western perspective, they do indicate size, scale and overlap, and the notion that some things are described as being nearer or further away. These conventions are all still used today.

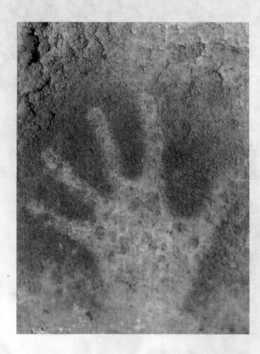

Hand ... Early Paleothic cave drawing, El Castillo, Puente Viesgo, Northern Spain *The hand, one of many in these caves, has a startling presence which links us over several thousand years to an immediate relationship with our forebears. Few images are able to demonstrate with such clarity the trace of a human presence.*

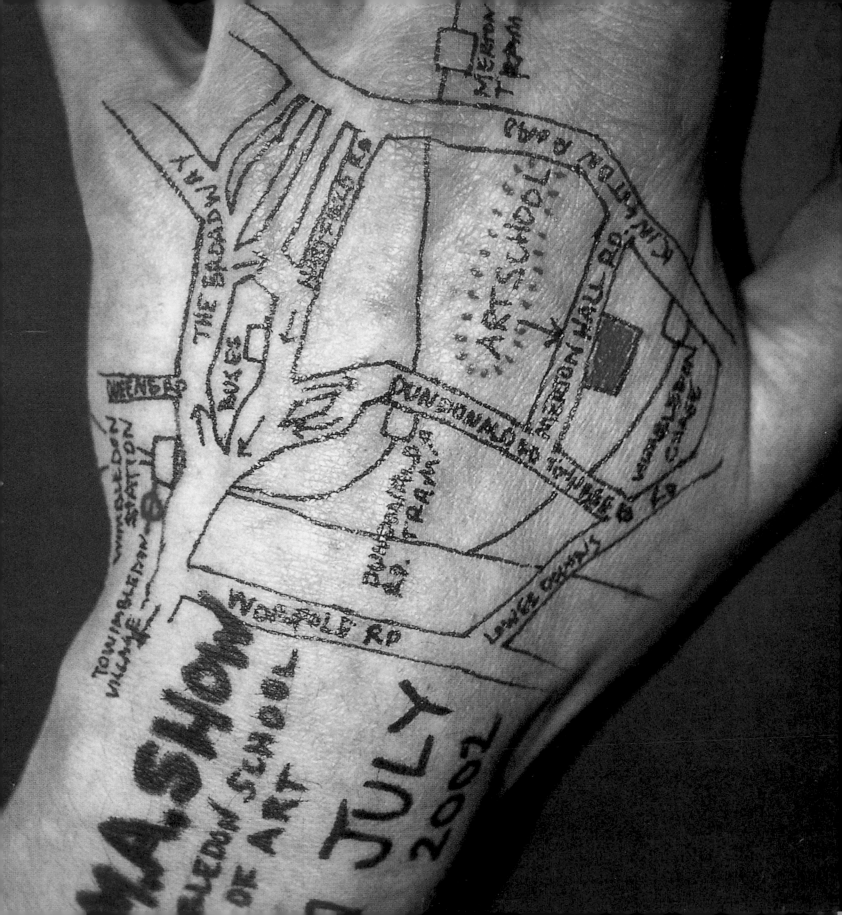

Diagrams and maps

Diagrams are a familiar part of our visual language – maps, plans and jottings on the back of a beer mat or an envelope to tell someone how to get somewhere, are all commonly used and understood. The coordinates marked on a map and our overhead view of them give us a recognised format within which to read or understand the whereabouts of a location.

Diagrams allow us to understand often complex objects in a simplified way. Their function is to pass on information succinctly. This whole idea of getting rid of irrelevant or surplus information is central to an understanding of the development of drawing, and the artist's urge to leave traces which are essential, uncluttered by attendant irrelevancies.

Surgeons rely on precise diagrams, made in fibre-tip pen on the human body, which confirm what is to be operated on and where incisions are to be made. Such diagrams do not contain emotional information about the pain or inconvenience that the patient might suffer. That is irrelevant in the present context, so is automatically edited out. Within each discipline, what is included and what is edited out defines the interests of the potential user of this kind of drawing.

As well as these functional diagrams, there is another kind of mapping that can produce unexpected results. Our charting of the stars led to recognisable images and associations being formed, as signs of the zodiac. These symbols, drawn from everyday experience, were easy for a largely illiterate public to grasp and were universally adopted.

Private View card, Wimbledon School of Art (2002), printed matter, pen on hand *This image, produced as a publicity card for a private view, demonstrates the way we use drawings to map location and indicate places that we wish to draw attention to; and the way we might notate information on the back of a hand as something important to remember and carry with us.*

German map of the heavens.

Distortion and deformation

The placement of images in complex architectural spaces, such as the Sistine Chapel with its barrel-vaulted ceiling, meant that artists at the drawing stage had to allow for some distortion in composition in order for the completed work to be viewed in its correct proportion. The distended hand of Adam extends over a curved surface and is greatly exaggerated; viewed from the intended distance, it appears to be in the correct proportion.

Artists working independently on easel-based paintings occasionally exploited the nature of accelerated perspectives. This phenomenon was known as anamorphic distortion, and often contained an image within an image, each separately readable from a different physical viewpoint. Thus Holbein's painting of *The Ambassadors* (1533) contains a memento mori in the form of an anamorphically distorted skull, which could only be read as one exited the room containing the painting.

The largest anamorphic distortion is a mural in Rome, 20 metres long. It depicts a linear landscape, but on entering the corridor at one end the viewer sees a full-length portrait of St Francis of Paola. This mural was completed by

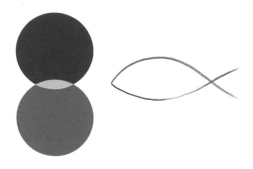

The Vesica Piscis, or fish shape, arrives from the meeting of two worlds as represented by two overlapping circles. The linking of these two worlds was initially a matter of religious conviction and subsequently one of formal interest. Geometry and theology then became inextricably linked.

Erhard Schon, *Anamorphosis* (1535), engraving
This 'apparent landscape' is in fact an image made to mark the treaty between Charles V, Ferdinand I, Francis I and Pope Paul III. This can be re-viewed by holding the image up and viewing from the side.

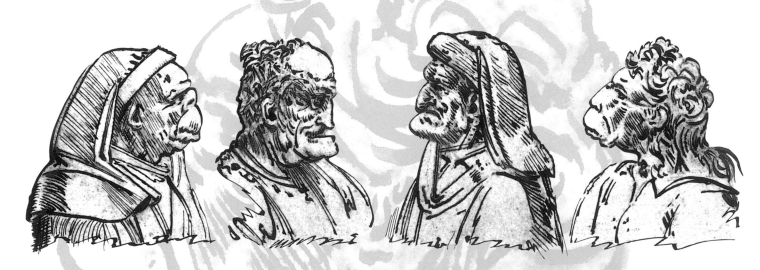

Emmanuel Maignon in the 16th century. Such distortion inevitably requires substantial planning to work out the complex and accelerated perspective as a drawing beforehand.

The relationship of distortion to deformation is an intriguing one. Viewing the drawing by Leonardo da Vinci (1452–1519) of four grotesques, illustrated here, one is prompted to relate them to more harmonious and naturalistic faces. In fact they only become grotesque as a result of our knowledge of what is considered harmonious; within their own time they were seen as distortions.

Velasquez (1599–1660), one of the great naturalistic painters of all time, was intrigued by people who did not conform to a physical norm. It is only within a naturalistic language that one can convincingly deal with abnormality. How to paint a likeness of a deformation concerned him. He established a naturalistic visual language and then tested how it could convincingly deal with physical abnormality. Imagine the difficulty in painting a figure with a withered hand. Within your visual language, you would first have to

establish a norm in order to instil confidence in the spectator that it was the subject that had changed and not the language.

The great gift of Picasso (1881–1973) to the 20th century was to reinvent a language which was capable of dealing with emotional extremes. From this standpoint, a reappraisal of Leonardo's distortions would allow us to redefine them as deformations. Picasso offers us an extension to childhood invention with his haptic distortion (distortion for emotional emphasis). The results have such intensity that they overwhelm our usual language and allow us to feel our way into new shapes and forms. It is as if he has invaded our bodies to re-shape our emotions.

Paul Thomas, Copy of Leonardo's Grotesques (2003), pen and ink, wash on paper *This copy of a Leonardo da Vinci drawing explores the way in which he used pen and ink to depict, catalogue and compare the grotesque heads of characters of his time.*

Drawing after Picasso

The Weeping Woman

To understand how another artist has composed and made decisions about their work, it is helpful to copy them ourselves, as with this version by Paul Thomas of Picasso's *Weeping Woman* (1937), and other examples used in this book. This process gives us the opportunity to contemplate the meaning and impact of an image by absorbing the type of drawing it is, the methods used and its overall feeling and atmosphere.

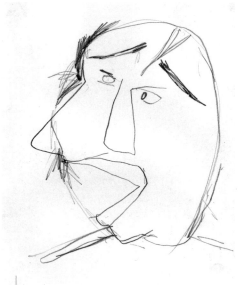

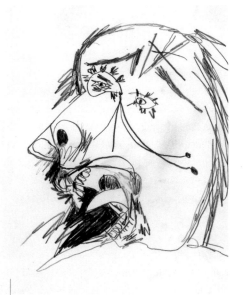

1 | *We start with an 'idea' of a face that is malleable and contains a potential for sadness. The eyebrows are pushed up and the mouth opened.*

2 | *The expression is exaggerated further and the head turned. As it looks around for support, the mouth opens in an unspoken but real gesture.*

3 | *Developing the mouth gives a more animalistic growling expression, replacing the gesture with a cry. The darker marks surrounding the mouth allow movement from the cavity into the light. The head seems to choke, the tongue wedged back into the throat.*

This copy of a study for *Guernica* (1937) is a good example of Picasso's haptic distortion. Here he creates a hybrid between a baboon and a woman, which explores fundamental loss and overwhelming grief and involves the artist in a startling struggle to reform a meaningful persona He deprives his viewers of usual recognisable features, as this head both turns and rotates upon its own axis, unsettling and challenging our ability to offer any more than empathy for her plight. The scratched marks that etch her face, squeezed from teardrop eyes, have a quality of helpless negation as we edge our way towards understanding. The baboon-like mouth, with its choked tongue, caught like a foreign object in the gullet, ensures that this primeval scream exists in silence for all time. As I copied this drawing, which I have long admired as one of the great drawings of the 20th century, I was shocked by the power such a small image could exude. This is haptic distortion, and it is to Picasso that we must look for a comprehensive examination of this new language. The whole concept of two eyes on one side of the nose is predicated on the notion that were this person to enter the room, they would not be seen as one of Leonardo's deformations but as the plastic equivalent of a real human being. In this case, freedom from naturalism equals greater expression.

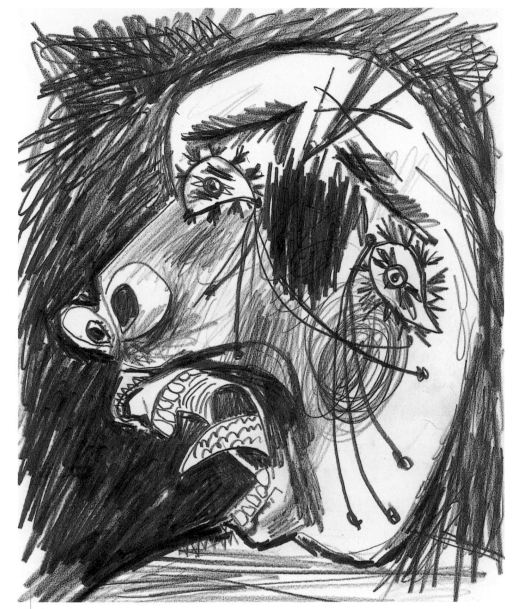

4 *The head turns back into the neck, rotating on its own axis. The eyes are separated and pulled outwards. The face is cut and scarred by marks flowing as tears, and the frenzied mark-making beyond the form both contains and agitates the baboon-like face.*

Sketchbooks

Sketchbooks provide a portable and convenient method of drawing, and are used to record significant thoughts, notes and ways of visually recording experiences. A sketch containing ideas for other works may well be codified and annotated, and may never be intended for anyone else to see.

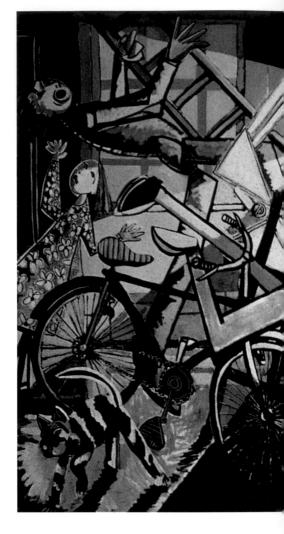

This explains the carefully guarded privacy of notebooks, and stories such as that of Francis Bacon (1910–92) destroying his sketchbooks once his gallery indicated that they might wish to show them, something for which they were never intended. The practice of keeping a notebook, journal or sketchbook is fundamentally practical – it provides a testing ground for all manner of visual thought processes.

Sketchbooks, notebooks and drawing pads are available in a range of qualities and sizes, and to suit specific purposes. They are generally made of multipurpose cartridge papers and may be spiral-bound or glued so that sheets can be torn out of the pad and used as reference material, or they may be bound books with hard covers, where a sequence of thoughts, drawings or notes can be kept together as a visual diary. Watercolour blocks are good-quality watercolour papers, made from separate sheets glued together in a block, so artists can work with wet media without stretching the paper. The sheets may be peeled away after they have dried. Using simple bookbinding techniques, you can make customised sketchbooks from the papers you prefer for your work.

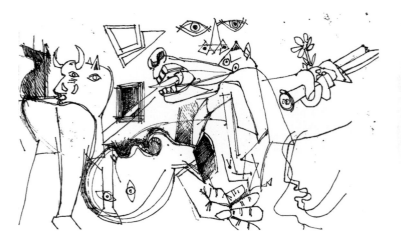

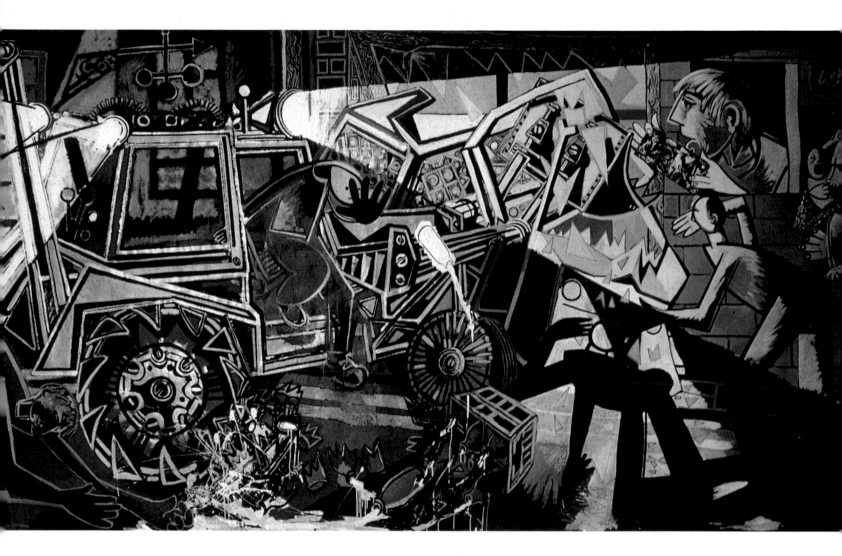

ABOVE Paul Thomas, *Spilt Milk* (1985), paint on paper, 7 m x 2.29 m
In this 7-metre painting, a mechanical digger collides with a milk float in a busy street, in a direct parody of Picasso's Guernica.

FAR LEFT *Elements taken from Guernica hint at the potential of parts to be morphed into the structure of the digger.*

CENTRE LEFT *Mechanical diggers removing a statue - it is this destruction of an established icon that sparked the initial idea.*

LEFT *This shows the idea of a collision between the digger and something vulnerable, witnessed by innocent bystanders.*

Recording directly

Imagine a sketchbook by J M W Turner (1775–1851), or perhaps several, completed during a visit to the Italian lakes in the early part of the 19th century. To reach his destination, in those days he would have had to catch a cross-channel sailing ship, with all his equipment, money and personal baggage, and travel overland through often inhospitable countryside for several days.

On his journey, he would have risked not only relative isolation but also possible attack by brigands, before he finally arrived at the lake. There, his routine was to walk round the shore, making a new drawing or watercolour every three minutes. Imagine what a daunting task this would have been over a two-week period, and the sheer energy involved in such an enterprise.

Landscape drawing can easily become formulaic with its constant repetition of foreground, middle distance and horizon. Turner, however, found many inventive solutions to this familiar formula, something that makes his achievement even more special. (The complexities of landscape drawing will be dealt with in the section 'Drawing as Record'.)

We look now at a drawing of an event. When Leonardo da Vinci made his *Study of a Hanged Man* (1479), he was probably a member of the 'academy' set up by Lorenzo the Magnificent to enable talented youths to work among the Medici collection of antique sculpture in Florence. This image of a hanged man states the record of a real and vital event. Leonardo drew this encounter with great pace, evident in the bluntness of the marks and the drawing as a whole.

It was Goya (1746–1828) who asserted that an artist had only a few seconds to draw a hanged man before the feet stopped kicking. He was referring to a phenomenon that is all too obvious for artists who have tried to use drawing as a means of recording an event. The artist needs to be well prepared, with the right materials to hand, and constantly ready as the moment approaches, as well as convinced of the importance of his task.

Today the camera has largely usurped this role. The speed and complexity with which the camera can record a scene is truly remarkable. The movie camera is even more remarkable, adding motion and sound to the already complex process. Given this competition, what can the artist offer? In the courtroom, where cameras are banned, artists are called in to make 'likenesses' of defendants and prosecutors alike. The results of these neutral recordings would certainly be less interesting if we were allowed photographic likenesses. By default, in areas where cameras do not have access, drawings become a reasonable substitute. However, is this all that we can expect? Surely the act of recording is not tied solely to achieving a likeness. In fact, the artist can

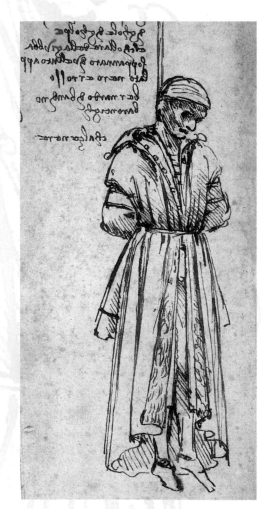

make a more valuable contribution through his part as a mediator in the communication of the event. This is what gives the act of drawing its true value.

War artists have traditionally been sent to the front to record the actuality of battle. Until fairly recently, this was the accepted method; the security of the armed forces' activities was protected by the natural delay in the availability of the images. Today, this reporting role has been substantially reduced by the advent of digital cameras and the recent practice of journalists being 'embedded' with the various fighting units. However, it is still thought important to appoint war artists as commentators on the experience of each war zone.

Furthermore, the idea of the 'truth' of the camera is now challenged by the potential for photographic images to be manipulated by computer. The camera's insistence on a single viewpoint, and its total record of the context of an event, exclude the possibilities for drama that an on-the-spot drawing can provide.

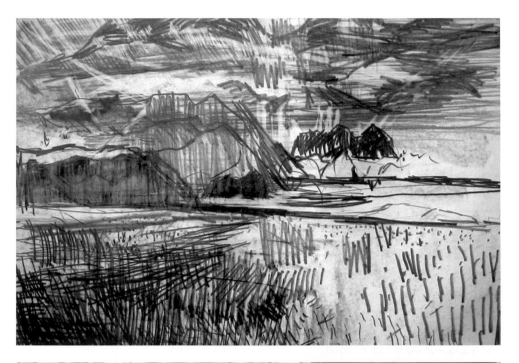

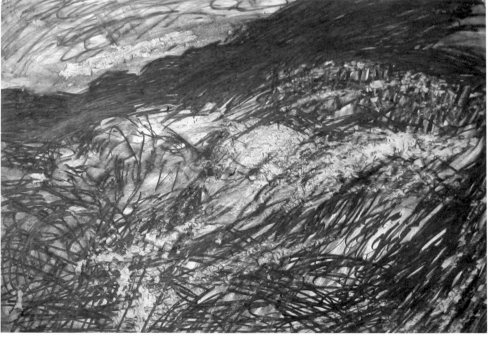

OPPOSITE: Leonardo da Vinci, *Study of a Hanged Man: Bernardo Baroncelli, Assassin of Giuliano de Medici* (1479), pen and ink on paper, 19.2 x 7.3 cm

RIGHT: Chris Thomas, *Towards Tintagel* (2002), pencil and graphite on paper, 58 x 84 cm

BELOW RIGHT: Chris Thomas, *Wind, Sea and Grass towards Pentire Point* (2002), pencil and graphite on paper, 53 x 76 cm *These two drawings attempt to record climatic and temporal transitions through equivalent mark-making. The drawing below both depicts and has been affected by driving rain. The mark-making here is the real product of drawing in a thunderstorm.*

Anatomy drawing

The practice of human dissection was essential to the development of understanding of the human body. Its main function was to inform surgeons and the medical profession, and the production of instructional anatomical drawings was essential. The combined interests of art and medicine resulted in the extraordinary anatomical drawings of Leonardo da Vinci (1452–1519).

Leonardo's voracious appetite for exploration through drawing included significant anatomical drawings which were bound into volumes and used by other artists, such as Rubens (1577–1640), to inform their work. The heroic exploits of the early pioneers of anatomical study cannot be overestimated. Without modern refrigeration methods, how did George Stubbs (1724–1806) dissect a complete horse without contracting a life-threatening disease? Similarly, those who dissected human bodies taken from the streets ran extraordinary risks. Then there was the sheer difficulty of the task itself. Imagine the two processes of dissection and drawing having to take place simultaneously.

To help the spread of information about the structure of the human body, instructional wax models of the human body were cast in exquisite detail from cadavers. Notable examples by Clemente Susini (1754–1814) are held in the Specola Museum, Florence. These models have remained influential among artists. Similar inspiration and accessibility is provided by the recent pioneering techniques of Gunther von Hagens (1945–) in plastination, a process in which the body is preserved by replacing the water and lipids in it with reactive polymers. The tradition of teaching anatomy, with instruction and dissection of the cadaver, is still taught at the Ruskin School of Drawing, Oxford University. This is very rare in art education today, although highly informative and inspirational to many artists.

This drawing by Sarah Simblet, a British artist and author, is of particular interest because it describes the linear relationships of the interior and exterior body, with cut-through cross-sections of the body, the artistic equivalent of the dissector's knife. Her drawings are made from direct observation. The lines in this drawing appear to have a slight wobble, if you look closely; this is not an affectation or stylistic device but simply a by-product of working in a morgue in very cold conditions for a long period of time. Furthermore, she wears gloves while working to prevent hepatitis and other blood-borne diseases, and this further muffles the sensitivity of the hands, and influences the resulting linear description, made with fine pencils.

Sarah Simblet, *Anatomical Study* (1997), pencil on paper, 34 x 60 cm

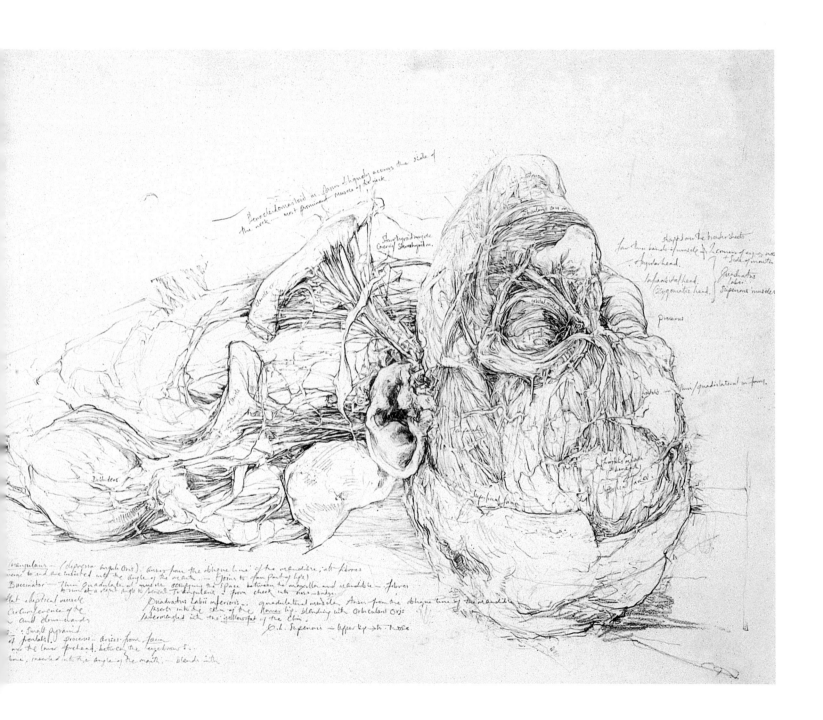

Drawing from still life

The genre of still-life quite literally gives the artist time to see life held in suspension. The world moves so fast that our ability to record it with any degree of factual accuracy is often lost. An art school witticism is that 'it may be nature morte, but it's still life', parodying the great French artists who used still-life as an essential part of their practice, from Chardin to Braque.

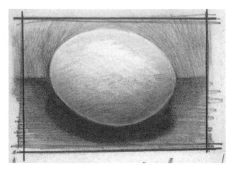 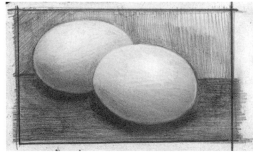 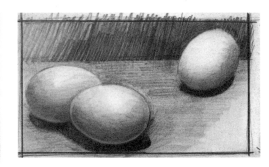

The drawing of still-life subjects enables artists to record the temporal nature of objects, such as fruit or flowers, by observing the qualities of light, or the delicacy and structure of the subject, or to describe it in a state of decay. Drawing a still life offers a manageable arena, in which apparently modest relationships can be teased out. The genre has also helped artists such as Braque and Picasso in the Cubist period (c1907-14) to explore the language needed to depict the essential qualities of the subject. Cezanne's oranges on a tabletop have a clear link both with his bathers, and his Provencal landscapes. This kind of drawing seeks to understand formal relationships without being overburdened with a complex synthesis of form to subject.

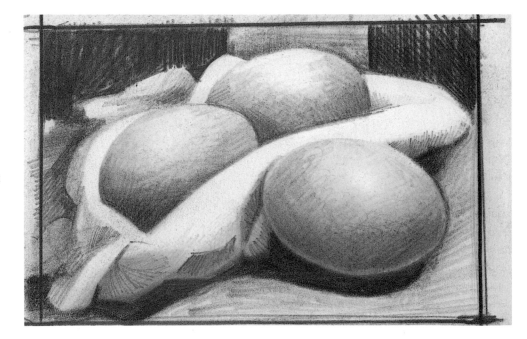

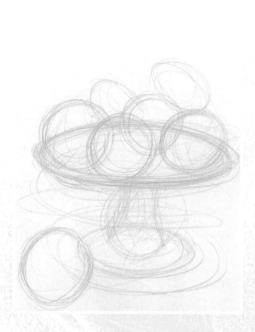

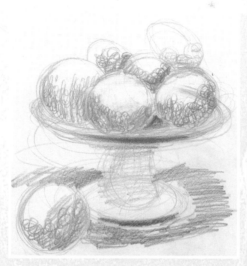

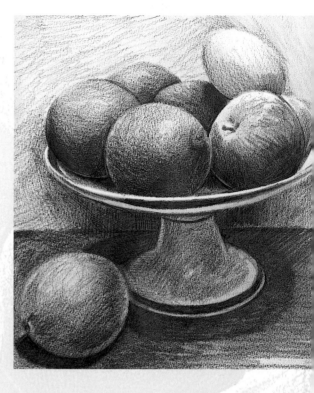

There are, of course, artists for whom the still life is an end in itself, and the carefully modulated images, made by Morandi, are an example of still lifes, which transcend their modest subject matter. So, still-life drawings can fall into two categories, they can either provide universal information about how a form exists in space, or seek to establish very particular elements for examination.

It is important to identify what it is that you would wish to understand from a still-life. Objects should be brought together primarily for their formal properties, rounded, square, sharp, thin, soft, hard, light, heavy, fragmented, liquid, clear, opaque etc and a drawing seeks to clarify this property whilst opening up potentially new relationships. For example in order to explore the modulation of light falling across a rounded

form, the subject of an egg, or eggs, provides a perfect opportunity. The egg becomes a basic building block, which stands as a surrogate for all rounded forms, and an essential building block for anyone with aspirations to make naturalistic drawings from a figure.

Most of the time the still-life grouping is seen from a fixed point, but at the beginning of the last century artists were interested in re-positioning themselves in relation to a still-life and began to physically move around the subject. This would offer new and exciting combinations as spacially complex objects, eg: a chair, could be re-formed in relation to a flat surface, as one examined it from different angles. It may be interesting to note that an egg would offer less potential for this kind of drawing, so, object selection is important.

OPPOSITE: *Start with one egg. This exercise is very simple and will get you used to describing the modulation of tone across a rounded surface. Two eggs allow a relationship to exist between two rounded forms and a flat plane; three eggs allows for a development of the space between objects. The three eggs and the material let you explore changing surfaces.*

ABOVE : *As you let the pencil move swiftly around the paper, start very generally to lasso the roundness of the forms. This movement should be made lightly and the tone increased gradually as you become more certain of where things are placed.*

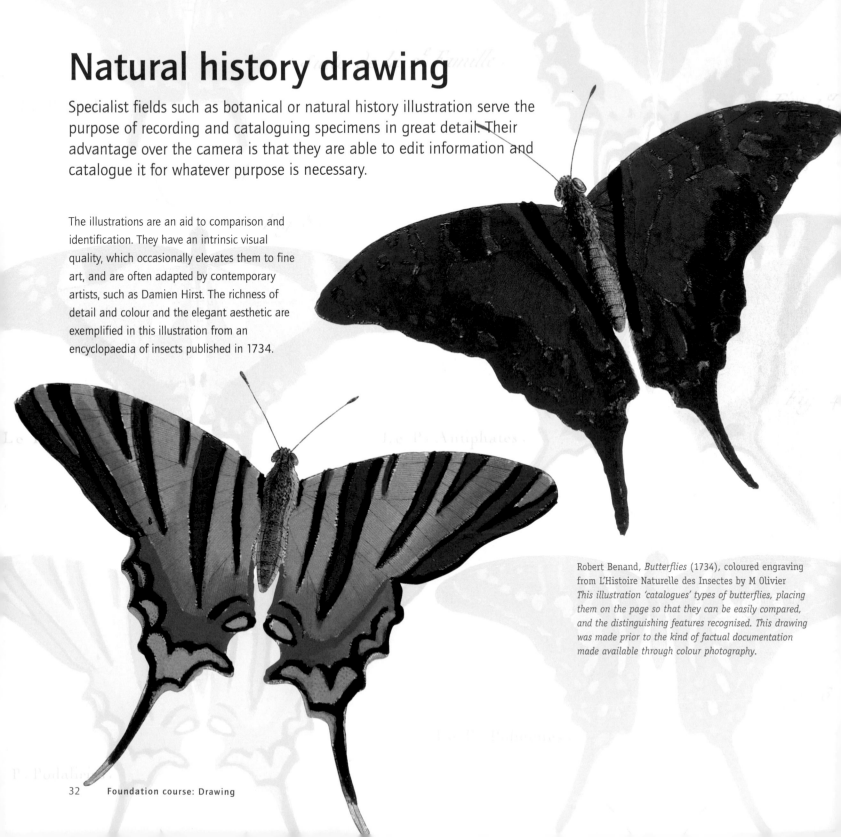

Natural history drawing

Specialist fields such as botanical or natural history illustration serve the purpose of recording and cataloguing specimens in great detail. Their advantage over the camera is that they are able to edit information and catalogue it for whatever purpose is necessary.

The illustrations are an aid to comparison and identification. They have an intrinsic visual quality, which occasionally elevates them to fine art, and are often adapted by contemporary artists, such as Damien Hirst. The richness of detail and colour and the elegant aesthetic are exemplified in this illustration from an encyclopaedia of insects published in 1734.

Robert Benand, *Butterflies* (1734), coloured engraving from L'Histoire Naturelle des Insectes by M Olivier
This illustration 'catalogues' types of butterflies, placing them on the page so that they can be easily compared, and the distinguishing features recognised. This drawing was made prior to the kind of factual documentation made available through colour photography.

Telling stories

Although the subject of illustration covers a vast area, artists have often been contemptuous about the term 'illustration' being applied to their work. There is an enormous range of narrative imagery, which is inevitably linked to texts. Stories from the Bible are indelibly linked to pictures in our minds.

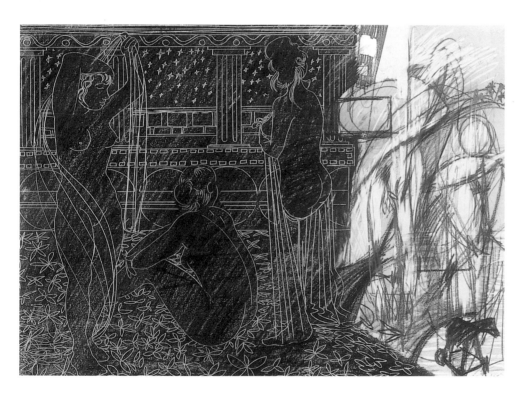

Pictures interpret text, and so our idea of Christ is made in the image of Michelangelo. Rembrandt's biblical interpretations are of quite a different order, but they interpreted the meaning of the text for Rembrandt's generation. As we move through the centuries, the constant re-evaluation of classical and biblical texts has engaged many great draughtsmen.

Paul Thomas, *The Judgment of Paris* (2000), graphite on paper, 56 x 76 cm *This drawing is the second image in a sequential series of 68 drawings to Homer's* Iliad. *It depicts Paris having to decide which of the three goddesses is the most beautiful. The drawing uses a polished graphite surface over an incised line to depict the three goddesses and promote a dream-like quality as they appear within the night. The light, which interrupts the image from the right-hand side of the drawing, indicates the intrusion of Paris into this boudoir scene.*

Preparatory drawing

There are several strands to the idea of an artist using drawing as a means of recording events in the world, and a distinction must be made between drawings which record an event and those which re-stage an event. For the latter, the artist invents what the event may have looked like and then records this view with surrogates. In a sense, the artist 'collages' the factual recorded information with the invented contexts, and it is the seamless fusion of these two worlds that allows us to suspend our disbelief.

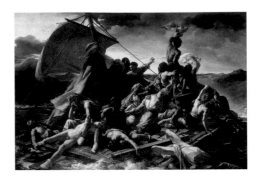

OPPOSITE: Théodore Géricault, *Two sketches for The Raft of the Medusa* (c 1819), pen, ink and wash *These preparatory drawings explore and test the overall composition of the final painting. Compare the way in which Géricault has explored the formal variations of the direction of the raft; the incidents that occur between the characters on the raft; and the sense of drama added to the one in which the raft lifts from the sea. This was the composition he selected and developed for his monumental painting.*

Géricault's *Raft of the Medusa* (1819) is a good example of a real event being re-invented for a painting. There are numerous studies for the painting, a good proportion of which contain variations on groups of figures cast adrift on the sea and waving to a ship on the distant horizon. These composition studies are informed in their parts by a series of drawings, made from both live models and cadavers, of which Géricault left a comprehensive record. Studies range from flayed limbs to portraits, as he searched for definitive information about the human form. Géricault imagined human bodies in a pictorial space, in response to the formal needs of the overall composition. The mast, which should form an assuring vertical, tips off the vertical and destabilises the horizontal plane below (the raft), and the figures move precariously across this shifting plane trying to retain their balance, both on the raft and within the picture. Figures fall conveniently within structural diagonals that criss-cross the surface, holding most, though not all, the figures in a contained structure. Two figures extend beyond this: one slips into the water, while the other raises a shirt into a more distant horizon. The figures would have been informed by the anatomical studies made by Géricault, and he would also have sought information from artists of the past, such as Rubens (1577–1640), while figures from other works of art would have been transported from one image to another, either as direct quotes or as a homage.

This practice of quoting other artists has been well researched. One only has to point to an elegant lineage from Giorgione's Concert Champêtre (c 1510) Raphael's *Judgment of Paris* (c 1513) and Raimondi's contemporary engraving, to Manet's *Déjeuner sur l'Herbe* (1863) and Picasso's later versions of this subject (1960–1), to recognise that direct quotation from another artist's work can lead to a clear re-evaluation for successive generations. Raphael's original image was itself adapted from two sarcophagus reliefs. What in Giorgione was a gentle pastoral idyll is in Manet a more acidic confrontation laced with an irony that Picasso exploited with great humour a hundred years later.

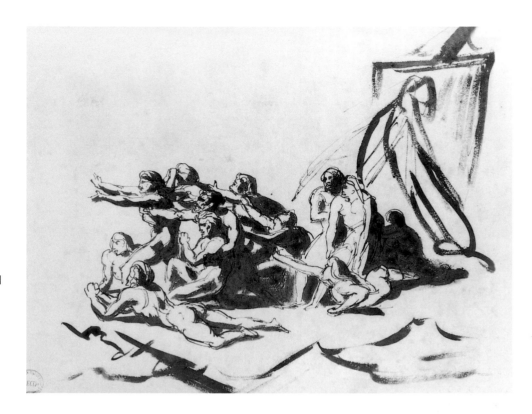

The process of artists using other artists to help them form complex configurations of people is much like a game of chess, in which the board and the pieces remain the same but there are endless variations, allowing for a succession of new conclusions. One of the attractions for an imaginative artist is to work in a predictable area making unpredictable and inventive connections.

Treatments by Cézanne (1839–1906) of mundane objects from the world around him – a plate, a knife, a table, a cup, some fruit – led to surprising results that question the way we see and what he considered an inappropriate and archaic system of representation. His questioning became instrumental in revitalising the inventive nature of drawing, as he struggled to break it free from slavish imitation and naturalistic representation. In doing so, he sought to establish some basic principles, which built on the art of the past but forced it to confront the natural world. He described his aim as 'to remake Poussin, but before nature'. When Cézanne picked up some apples and placed them on a table, he became interested not only in the form but in the field between the forms. This is much like the Magdeburg hemispheres with their crackling of electricity between two metal spheres. It is what Michelangelo wanted to happen between the hand of Adam and the hand of God on the Sistine Chapel ceiling, but where Michelangelo illustrated the idea, Cézanne embodied the principle.

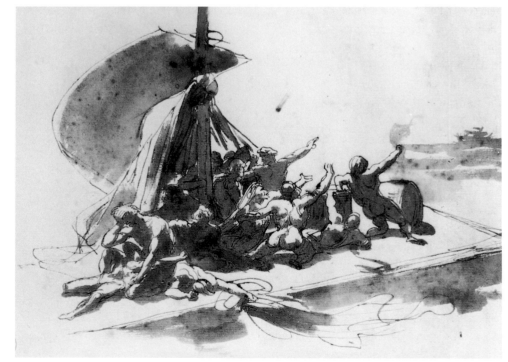

Technical drawing

This type of drawing, often accompanied by measurements, allows a third party to visualise a three-dimensional project and re-present it in two-dimensions. Thanks to the remarkable capacity of the human mind, whole cities can be invented on paper, and within this almost limitless concept, our interpretation of space through diagrams is only bound by our imagination.

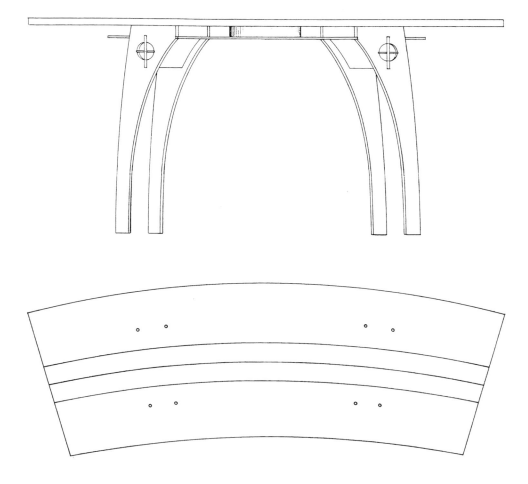

Aled Lewis, furniture design for the Altar for the Convent of the Mercy Midhurst 2002. *Numerous drawings are produced for each design, indicating different aspects of the design process. This drawing indicates the materials that the altar will be made from, while indicating the proportional measurements of the design, without the need to indicate the specific size. Here the designer is more concerned with the clarity of line presented by the altar, with little unnecessary detail. Any pretence at illusion is completely eliminated.*

A marvellous example of this is the theory that a real object could be placed on the surface of Mars, and from a diagrammatic proposal for putting a space craft in orbit around a planet, an actual vehicle designed through drawing was placed on a surface that had never been seen, at a distance that had never been travelled and from working drawing to fully-functioning device images of great detail were transmitted back to a base on Earth.

In this instance, what started perhaps as a doodle on a paper surface, as an imaginative and inventive concept, became realised in actuality as a real object on a red dusty surface half-way across our solar system.

In order to make an object, the constructor needs a drawing broken down into three, sometimes more, categories. Most design drawings therefore contain a front plan and side elevations, to explain the proposed appearance of the object, building or, machine to a maker or commissioner.

This stage of design process uses a formalised system of drawing to enable a fast and fluid understanding of the scale, proportion, measurements, and overall concept, which is likely to be a stage development from an initial sketch or idea. This realisation or re-presentation of the initial concept may contain increasingly sophisticated levels of detail, as more information is required to realise the specifications to third parties - the makers, construction workers, structural engineers, finishers, health and safety authorities, insurers and aesthetes - as one tries to accommodate an ever-widening circle of those involved in the realisation of the project.

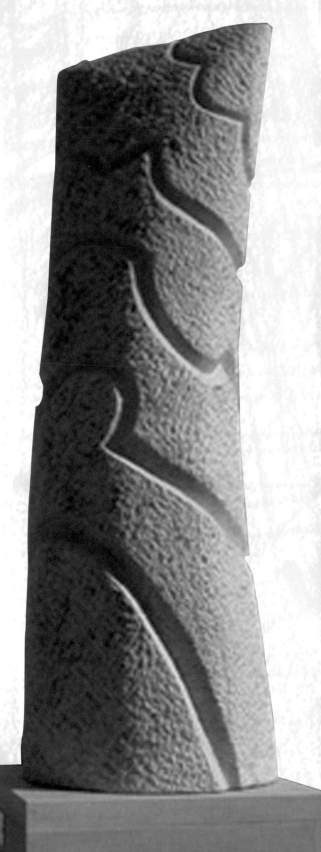

Paul Mason, *River Tide Cut* (2003), marble
The drawing for this sculpture indicates the overall shape and the kind of marks that were to be imprinted over the surface by carving. The drawing was used as part of a proposal for a public art commission to suggest the kind of sculpture to be made and how it would relate to the commissioned theme. The actual sculpture was then made, and while it relates strongly to the initial proposal, in the making process the motif of the lines, which describe or suggest ripples of erosion, are incised and respond to the nature of the material used.

Drawing as decoration

Decoration is an embellishment around a single idea, with a central motif containing echoes of itself in the surrounding area. In Rococo drawing this reaches fabulous heights, with endless flourishes that reverberate throughout the image. One can imagine endless bowing and doffing of caps as artists retreated to the edge of the page.

Decorative design often depends on the creation of small pattern, which is capable of staged repetition, for example William Morris and his complex floral motifs, which allow for substantial areas of material or fabric to be covered in a satisfying multiplication of the original motif. This is distinctly different from Rococo embellishment. Both are decorative systems, which are equally applicable to ceramics, wallpaper, textiles and gardens.

The urge to decorate, or cover a surface is very strong, and has resulted in a long history of different styles and systems applied to numerous artefacts in many differing cultures. It has been a crucial, almost instinctive form of drawing throughout history.

There is a long tradition of freehand blue and white decoration on ceramic. This large jar, the product of Isis Ceramics, has been decorated using very fine brushes to apply coloured pigment to an already glazed and therefore fragile surface. On the left is the jar in its biscuit-fired state ready for glazing; in the centre, the jar has been glazed and then painted with the pigment glaze; on the right, the jar has been glaze-fired and is complete, as in the detail shown opposite.

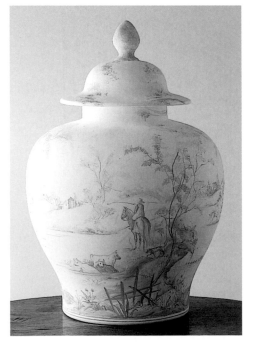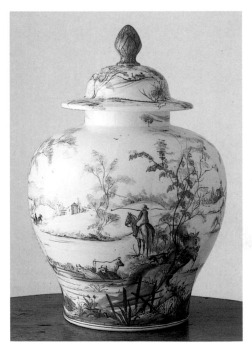

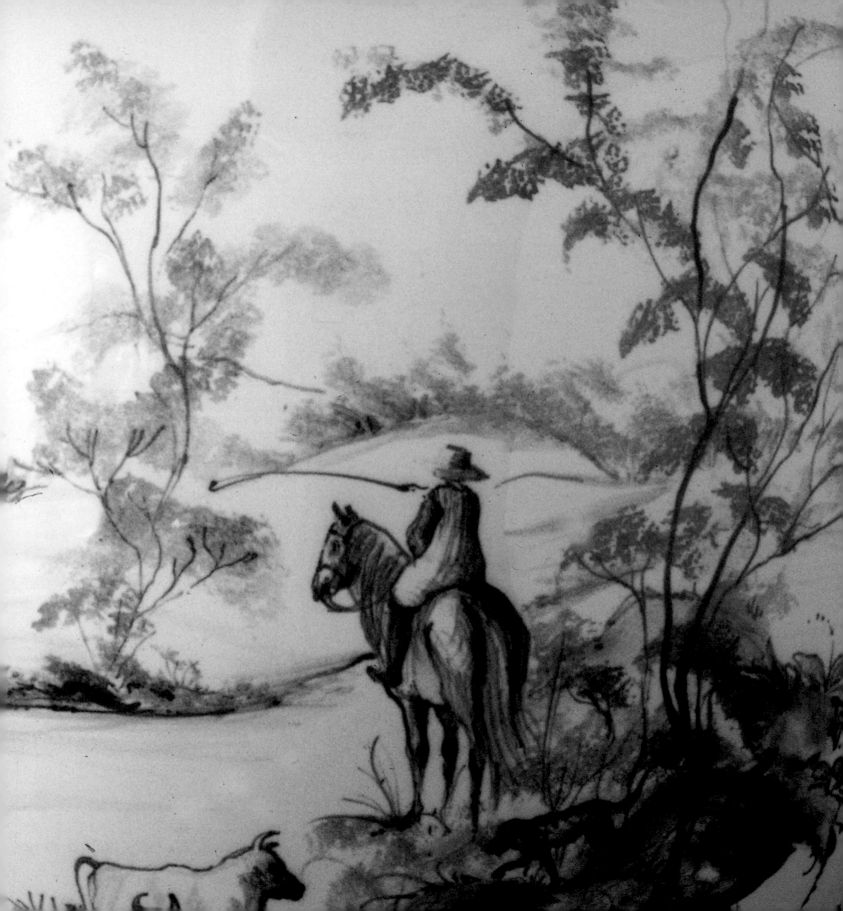

Cartoon and animation

In a process that begins in naturalism or observation, then moves through formalisation and stylisation, images become cartoons, able to comment on or invent scenarios for the static or still media, such as journals, newspapers and magazines.

The moving cartoon or animated film simply makes sequential narrative possible, leading to the enhanced development of the characters and the contexts in which they appear. With the advent of new computer technologies, cartoons and animated films have moved into spectacular new territory, exemplified by the motion picture *Shrek* (2002). It was noted by its makers that the princess became 'too real' and, in doing so, went beyond the bounds of fiction. This film in fact redefines the values and differences between the simulated and the real.

Undoubtedly, computers will revolutionise the way visual information is collated, manipulated and received. Ever more sophisticated programmes are challenging artists' traditional working methods.

However, when Picasso was asked whether the advent of photography meant that painting was dead, he declared that, on the contrary, 'Photography tells us everything that painting is not.' One might be tempted to make a similar bold statement about drawing and computers.

Anita Taylor, *Untitled* (1999), pencil on paper, 10 x 8 cm *In this image, a humorous comment is achieved by using distortion and over-emphasis of gesture, ridiculing the idea of women as sirens preening themselves and being aware of being viewed.*

The act of drawing

Increasing interest in Eastern religions has led many artists to regard drawing as a meditative act. The contemplation of the single mark, or the quiet accumulation of lines, can be seen to relate to Buddhist philosophy. The value of the drawing depends on the disciplined conduct of the maker.

The virtue exhibited in such formal language is born of a synthesis of physical and mental control. The process of making is the work of art. The marks of the drawing are the trace of the activity. At first sight it may seem 'easier' to ask a computer to plot the outcome. This would be missing the point as it is the excellence of control, combined with the potential for human frailty, that dictates the essential balance of the final image.

Artists are increasingly wanting to be true to the materials that they use, and many would find the idea of using drawing to illustrate objects in the world a fruitless and essentially false premise. There is the opportunity for artists to free themselves from literary burdens and illusion as they try to re-establish an essence and therefore a clearer meaning in their work.

David Connearn, *Holocene* (Cosgraves Prime) (2000), pen and pencil on paper, 193 x 168 cm *This image is made by drawing single lines, starting at the top of the paper, with the arm extended as far from the body as the artist can manage. As the lines accumulate, they form a relationship to each other.*

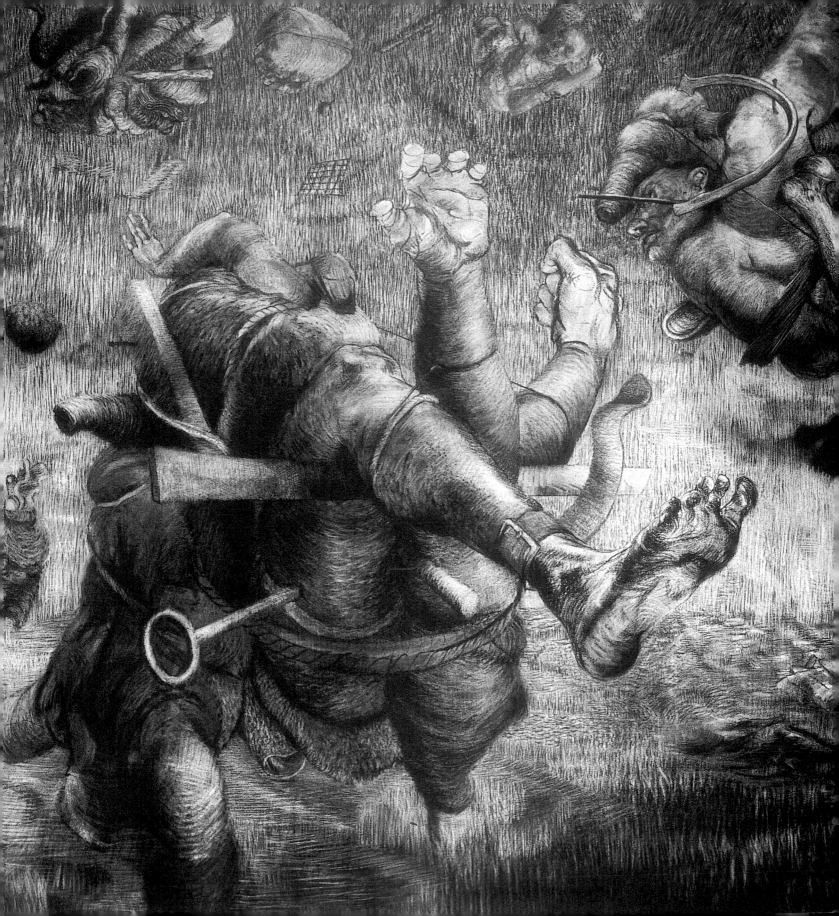

Drawing from the imagination

Drawing from the imagination is a misnomer. What is really involved is drawing from a reinvented world in which objects are placed in surprising contexts, allowing for a poetic re-evaluation of their function and purpose. It is the artist's responsibility to create a context for these objects to appear as part of a coherent unfolding narrative.

Thus dislocation, the scourge of many a collage, becomes an enemy promoting ill-judged or discordant relationships. Surrealism is the anarchic juxtaposition of one kind of reality in an unlikely context. Imaginatively based drawing requires clear editing and an overall concept that allows for a coherent language to be set in place. If the artist transgresses the logic of the image, he runs the risk of dislocating the spectator from a notion of insistent reality. It is the responsibility of the artist to maintain credible understanding throughout the whole process. Any wavering or wandering into other languages means the image may be reduced to a rag-bag of assorted stylistic possibilities or propositions.

Meaning is not something that artists should strive for. Others can place meaning on a work of art. A shopping list of intentions at the beginning of a drawing should have invention and clarity at the top. Some people would relegate invention, but all would maintain that clarity is the first premise of a good drawing.

The fundamental nature and purpose of drawing is to leave an individual mark on the world – I WAS HERE. It is the testament that for the time that I touched this I was alive in the world. It is the great I AM.

OPPOSITE: Gerald Davies, *Falling Figure* (detail) (1999), charcoal on paper, 152 x 102 cm. *This drawing depicts the tools, detritus and subject of a crime. The evidence and body are set adrift in a mindless, irresponsible void. The debris was erased and re-made many times, as a discursive process, sometimes measured and precise, sometimes gestural and ambiguous.*

BELOW: Judy Inglis, *A Child of our Time* (1994), charcoal, pigment on paper prepared with gesso, 117 x 137 cm *The carnivalesque nature of this image centres on an egg suspended in the middle of the image. The drawings include references to classical mythology and arcane rituals as well as to a narrative core which is autobiographical.*

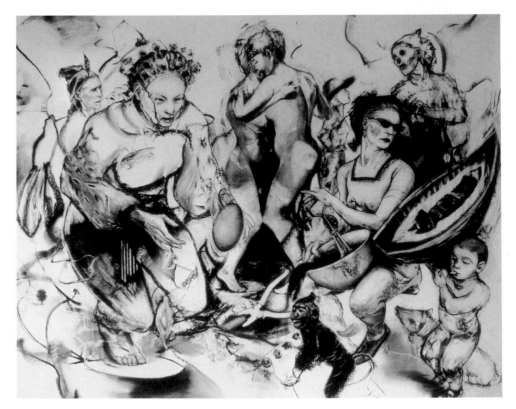

METHODS AND MATERIALS OF DRAWING

'. . . even in a prison, or in a concentration camp,

I would be almighty in my own world of art, even

if I had to paint my pictures with my wet tongue

on the dusty floor of my cell.'

Pablo Picasso, *Der Monat* (1949)

The importance of materials

Drawing can be the simplest and most direct activity, or an exploration using more sophisticated materials to realise complex ideas and perceptions. Picasso (see previous page) points out that we can make images by the simplest of means, with something wet in the dust - his tongue, our fingers, a stick in mud or on the beach.

Our instinct is to make images, and with the means we have to hand. Drawings can be 'found', and could be described as an imprint or a trace of humans on the environment, such as a track made in the snow, a drawing in the sand or the trail of an aircraft in the sky.

The notions of permanence and impermanence are important to the concepts of art, and while in the main the materials described below offer permanence, this assumes that you wish to make work for posterity. For some artists, and for some pieces of work, this is not an imperative – either because it is about exploring a fleeting thought for which no permanent record is sought, or for working drawings or notations for other work, or just playfulness, using the potential to make marks on impermanent surfaces.

An important element in making a drawing and realising your aims is the choice and selection of materials to work with. This choice will influence the 'reading' of your drawing and may serve as additional information to the embodiment of your ideas. This section of the book aims to cover the range of products on offer to the artist, and to help you to select the appropriate media to draw your subject with.

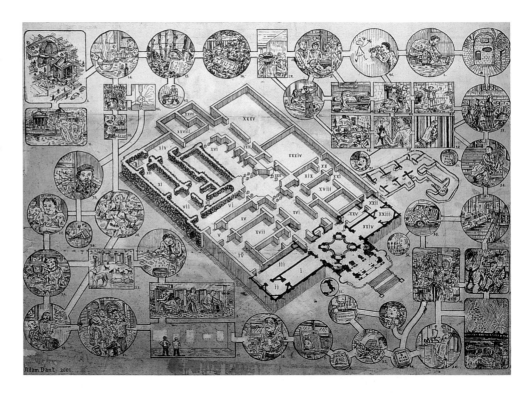

ABOVE: Adam Dant, *Anecdotal Plan of Tate Britain* (2001), ink on antique paper, 59.5 x 80 cm *This drawing was made for the centenary of Tate Britain, London. It combines images of daily events with the iconic imagery housed in the museum. They are depicted linked and framed, like the framing of a comic-book story, in the form of a dredged up document. The materials used, antique paper and ink, suggest and construct the conceit of an aged document.*

OPPOSITE: Jen-Wei Kuo, *Sea* (2000), charcoal on paper on canvas, 149 x 149 cm *This drawing is made with dust. The accumulation of charcoal dust over a period of time provides a tonal surface which then, after air is moved over it, is removed to draw lines and dots which form the image. This highly representational image is made, therefore, without the need to physically touch the surface – like a photographic image, which it resembles at first sight.*

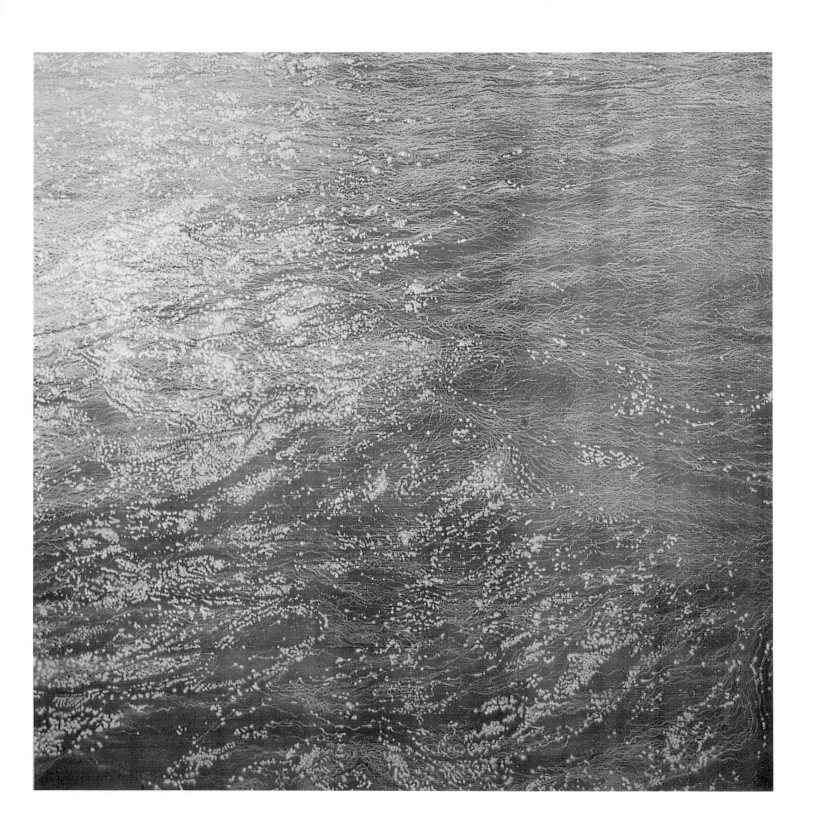

Choosing Papers

Paper is the most common material to form a support for drawing. A vast array of papers is available to choose from, made in various surfaces or textures, materials, weights and sizes, all designed for different purposes. This means that before you even begin to make a drawing, you will already have made a number of decisions which will affect the final work. The kind of marks you can make, the media you can work with and the size of your drawing are all influenced by these initial choices.

Art and non-art papers

Papers designed for artists provide a strong and durable support. Cartridge paper, made from wood pulp, may provide a good paper to work quickly and extensively on, but it will not sustain a huge amount of amendments to the drawing, as it is not terribly strong, may not be acid-free, and therefore may discolour over time. Likewise, newsprint may also provide a good ground as a sketching paper to work out composition or ideas, but it will not be durable either in terms of pressure applied or the lightfastness of the paper itself. Acidity of the paper is the cause of deterioration, and this is a result of using wood pulp and other untreated plant fibres, bleaches or dyes in paper production.

Paper is made from interwoven fibres, which in the case of fine art papers is usually plant fibre, although some synthetic fibres are used in commercial paper-making, for instance for the print and packaging industries.

Wood fibre is also used to make paper, with a mixture of differing lengths enhancing its strength. There are two types of fibre derived from wood – mechanical wood pulp and wood-

free. Newsprint and sugar papers are made from mechanical wood pulp, which is made by pulping the wood and binding it together with size. Wood-free paper is made by treating the wood pulp, removing the element of the fibre which yellows and through its acidity causes the paper to deteriorate, which gives a cheap, acid-free paper. It is, however, more common to find that the wood-free fibre derived from this process is combined with a proportion of cotton linter, which also makes a superior paper.

Fibres

Cotton linter is the fibre made from cotton plants, and this is a strong and acid-free fibre which forms the basis for most fine art papers. These papers are sometimes known as 'rag' papers, a name derived from the practice of making papers from old cotton or linen clothes, or rags, essentially cotton fabrics cut into small pieces to provide the fibre.

The best paper to use is that made from 100% cotton. This gives a strong, non-acidic material which lasts longest and resists discoloration and deterioration the most. This is essentially the paper of Western civilisations.

Japanese, Chinese, Nepalese and Korean papers use various indigenous plant fibres, producing very strong papers, made from very strong and long fibres. These make acid-free batches of paper, though not all such papers are acid-free and you should check this with the retailer, as it will affect how you use and store the paper. This is also true of khadi papers made in India. These provide a distinctive surface, but the paper, often tinted, is seldom acid-free.

Size

The interweaving of the fibres gives paper its inherent strength. This strength, needed by artists, is improved by the use of 'size' as the fibres may be too absorbent on their own and would disintegrate if they became wet. Size is a glue-like sealant, and can be synthetic, made from starch (cellulose) or gelatin. Papers are internally-sized or surface-sized.

For internal sizing, a size is incorporated into the pulp at the production stage, and this will ensure an even consistency of absorbency (or non-absorbency) throughout the paper, so even if the surface is rubbed away the paper will not respond in a different way to that of the surface. This makes internally sized paper good for working with wet media, as the pigment of ink or paint will sit on the surface as applied, without the binding agent being sucked or absorbed into the fibre of the paper.

OPPOSITE: *A selection of papers (from top to bottom): Arches Rough watercolour paper, 300 gsm; Khadi paper, 85 gsm; Khadi paper, 200 gsm; Fabriano* Roma *hand made laid paper.*

RIGHT: Annie Phelps, *Life Drawing (Derek)*, charcoal on cartridge paper, 122 x 91 cm *This student life drawing uses tone to modulate the light falling across the figure.*

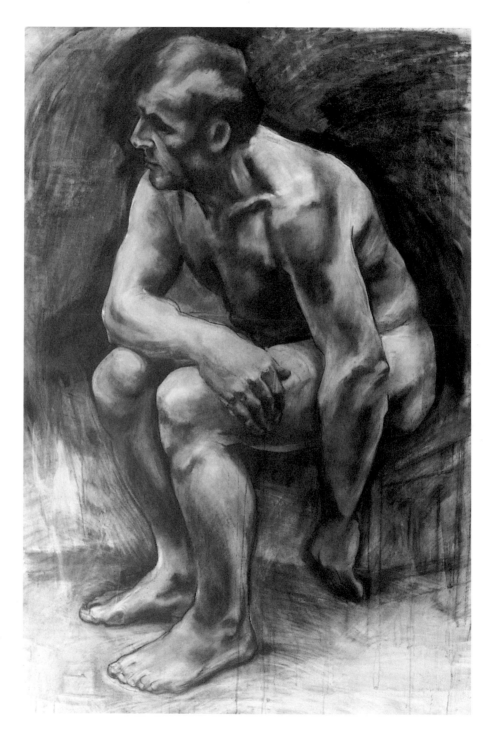

Surface- or tub-sizing involves the additional application of either a starch or gelatin-based size to the surface. Starch sizing smooths the fibres to improve the paper surface, while gelatin size is applied either in the mould-machine process or on to the dry sheet. This process toughens the surface and makes it more durable for heavily worked drawings.

Some papers are not sized in this way as they are designed for other processes, for which the size would be too resistant. Printmaking papers may be used for drawing but are designed as soft papers so that they can cast, or be laid on, the fine surface of a printing plate. These papers have a much lower level of internal sizing and are known as soft-sized papers. Other papers, known as Waterleaf, have no additional internal sizing so that they can delicately cast the surface of a plate when dampened. These papers should not be used for wet drawing media, and may be too soft for pencil drawings, but the softness of the surface may enhance the use of dry pigments or charcoal.

Surfaces

Paper surfaces vary according to the production processes used. Three surfaces are made for Western papers: Rough (R), Not or Cold-Pressed and Hot-pressed (HP).

Papers with a rough surface have the most textured surfaces, made by the blanket pressing on either side of the paper in the pressing process. This surface or 'tooth' provides a surface which will hold dusty or dry pigments most successfully, although the tooth may interfere with line.

Not or Cold-pressed papers are the result of the rough paper being pressed again, without the blanket, flattening the surface imprinted from the blanket. 'Not' is the abbreviation of 'not hot-pressed'. This surface is therefore smoother than the initial rough paper but still has a tooth to hold pigment or carbon.

Hot-pressed is the further pressing of the Not paper with a hot cylinder, bonding the fibres closer together through the application of heat to achieve a smoother and more finely textured surface.

Each make of paper is usually produced in two or all three surfaces, but the quality of each of the resulting surfaces varies from manufacturer to manufacturer, and you should try out a range of paper samples before choosing papers to work with. This is important as you will gain experience of the 'touch' or 'feel' of the papers, while also learning about the kind of surface you might need to work with using your chosen materials.

Papers are also made in varying weights. Fine art papers are usually made in the range 120–600 gsm (grams per square metre). Lighter papers may be available and oriental papers may provide some lighter weights, while others may be heavier. A good weight for a drawing paper would be in the region of 200–250 gsm, although some artists may wish to choose heavier papers. Generally, the heavier the paper the thicker it will be. The weight of the paper you choose will be significant, as it will affect the drawings you make, and you need to take account of your choice of media, choice of subject, and how much adjustment and change will take place within your drawing before you have finished with it.

Hand-made and mould-made

Hand-made paper is formed by hand on a mould, which is usually a frame with a mesh, and the fibres used to make the paper are spread and interwoven over this mesh to make a random structure which is usually stronger than that of mould-made papers, and gives the surface a distinctive and unique character. This method of making paper produces four deckle edges as a result of the sheets being made individually. Deckle edges are irregular and are the result of the fibres being pressed to the edges of the mould.

Mould-made papers are made on a large cylinder-mould machine, which spreads the fibres more randomly than machine-made papers, making it stronger than machine-made paper, but not as strong as hand-made. The process results in two deckle edges, formed at the edges of the cylinder, and two straight edges as the paper is cut to form the sheets.

Machine-made

Machine-made paper is manufactured on a machine, which makes the paper in one continuous process. The fibres are distributed in a regular direction, and all the resulting edges of the paper are cut.

Wove paper is formed on a woven mesh, and laid paper is made either by hand or on a cylinder-machine. The distinctive ridged surface of the paper is formed by the pulp being deposited and pressed on a mesh overlaid with wires at right-angles to the longer edge of the

OPPOSITE: *Drawings made with HB, 6B and 6H pencils on Rough paper(top), Not paper (centre) and Hot-pressed paper (bottom).*

Milda Gudelyte, *Establishing the Rules of the Game* (1999), ink on heavy watercolour paper, 10 x 15 cm
A fluid black-ink line is used to define the characters and activity within the image; this is then augmented with washes of coloured ink to add temperature and atmosphere. The colour is allowed to form areas independently of the line, a solution which is particularly apt for this subject matter.

paper. Machine-made laid paper is a wove paper embossed with a laid pattern. Laid paper is often used when making pastel drawings as the ridged surface holds the dry pigment. It is also available in a range of colours, which may provide a tint or temperature as a ground for working in colour. It is important to learn from the manufacturer how lightfast the colour or tint is, and whether the dye is acid-free, to avoid fugitive results.

Watermarks

Watermarks are made similarly to laid paper by forming the design of the watermark directly onto the mould by stitching or branding the mesh. Machine-made watermarks are embossed into the wet sheet. Watermarks identify the maker of the papers, and may differ in design according to the kind of paper.

The watermark also distinguishes the side of the paper to use. When the watermark can be read the right way round, this is the surface designed by the manufacturer for the artist to use. However, the artist may decide for various personal reasons to use the other side of the paper to work on.

Sheet sizes

Fine art papers usually come in standard sizes, although hand-made papers may have small variations. Indeed, special batches of hand-made paper can be commissioned to suit particular needs, and artist such as Jim Dine commission their own papers, working with specialist manufacturers to develop method-specific surfaces and sizes. However, the enormous range of fine papers available on the market means that this is a refined and

Robert Davison, *Covert* (1992), graphite and acrylic on paper, 80 x 112.5 cm *This drawing uses a fluid medium to suspend and disperse graphite powder. The resulting tone has a silver and black quality, and the marks emulate the liquidity of paint. This medium allows for a mysterious presence hinted at in the title.*

relatively unusual occurrence. Manufacturers make papers which are ideally suited to dry drawing processes, wet media, printmaking, bookbinding, calligraphy, etc. Imperial, half-imperial, elephant, double-elephant, and A sizes are all available. Paper is also produced in rolls made either by a mould-made or machine process. The manufacturers of these papers, for instance Arches in France, often make this paper in batches, so it may not always be as easy to find as the sheets.

Oriental papers

Japanese and other oriental papers are available in a huge variety. They are noted for their strength, allied to fine and often translucent qualities. The fibres in Japanese papers are highly particular, being taken from mulberry, bamboo, rice and other sources. The fibres used are long and highly varied in the highest quality hand-made papers, used for pen-and-ink work and calligraphy.

Other plant papers are available, usually hand-made in small batches using materials indigenous to the place of manufacture. Due to the modest production of some of these papers, the consistency and quality cannot be guaranteed, but they can lend a particular quality to the mark-making or surface features of your drawings. Papers from the Himalayas, called khadi papers, are often irregular in shape and use fugitive vegetable dyes to tint the papers.

Preparing papers

As a preparation for working with dry media, the surface of the paper may be tinted to give a more stable coloured ground than dyed papers, using pure dry pigments or pastels. The surface may also be adjusted to give more tooth to grip the marks of various media or mark-making tools by using an acrylic primer, or other water-based paint. If a combination of these two qualities is required, the paint may be tinted with liquid pigment or coloured paint. A coloured tint using watercolour paint or acrylic may also be applied to stretched paper.

Gesso is usually applied to a rigid surface as it is not inherently flexible. If applied to paper, this must be kept as rigid as a possible, either by permanently stretching the paper over boards, or it can be used as a surface to draw on when applied directly to MDF. It can also be used on very heavy paper which is firmly supported throughout. Proprietary priming applications (preparations for oil or acrylic painting) may be used, but the surface quality of hand-made gesso is significantly different and provides a receptive surface which enhances the tonal range of charcoal and is equally good for fine mark-making such as silverpoint. To make your own gesso, see page 55.

A selection of Japanese Mangeishi papers in a variety of colours.

Alternative supports for drawing

Vellum and parchment may be used for fine drawings, particularly in ink and with a prepared surface for silverpoint, and although almost obsolete may still be purchased from specialist suppliers. Parchment and vellum were used extensively before the advent of paper technology in the 11th-14th centuries, when paper as we know it today became extensively used. Many Old Master drawings were made on vellum or parchment made from the skins of very young calves, goats or sheep. Vellum, a finer kind of parchment, is made from calfskin, rendered white and translucent for very fine illumination and lettering. The size of this material is limited by the size of the animals involved in its production, and the practicalities of handling skins. The surface may be reused for new drawings by removing the earlier layer of drawing.

Drawings may of course be made on many different surfaces, including walls, blackboards, ceramics, canvas and earth. It is important that the surface and the quality of the marks or image work sympathetically together to render meaning. Rock or cave paintings use the shape and surface of the natural setting to inform the drawings.

Importantly, the surface needs a tooth or to be uneven to act as a file to the drawing materials. Many surfaces may need to be prepared to enable the drawing to transcend the initial quality of the surface, and this may involve priming a surface, preparing it with blackboard paint, or sanding a smooth surface to provide a tooth. Canvas may need to be stretched over a hard surface (usually board or MDF) to give it enough resistance to the hardness of a number of drawing materials.

Andrew Bick, *Bag Drawing 1 of 1*, marker pen on glassine bag, 54 x 43 cm
This drawing is made by inserting glassine negative bags inside each other in order to produce a layered image.

Gesso preparation

Gesso is made of animal glue and a mixture of white pigment and other inert pigment, such as whiting. The glue is made by soaking rabbit-skin size (85 g/3 oz), which is available either in granule or sheet form, in 1.4 litres (2 pints) of water in the top part of a double boiler. This needs to soak for about two hours, and then the pan is heated and the glue is melted and left to set in a cool place. The set glue should resemble fruit jelly, which should split to be firm and tough. The proportion indicated here is approximate and you will need to adjust for each batch of glue size bought. If the support, paper or board is not sized prior to the application of the gesso mix, it may sink into the support and leave a residual and weak layer of pigment on the surface. To size the support, dilute this glue mix by 50% using hot water, and then heat the glue in the double boiler, but do not let it boil. Apply the size while it is warm. Paper will need to be stretched prior to this application unless it is very heavy, over 400 gsm.

To make the gesso itself, mix 450 g (1 lb) of whiting and 56 g (2 oz) of titanium white pigment together while dry, to disperse the titanium through the whiting. The titanium white pigment improves the whiteness and opacity of the gesso. Traditionally, lead or flake white was used, but this is highly toxic and is not recommended for use as the dry lead pigment may be absorbed through the skin and inhaled into the lungs. Heat the original glue solution, and put the dry pigment into a spare top pan on the double boiler, with the heat source on the lowest setting. Gradually pour glue onto the dry pigment, stirring all the time, and mix to a lump-free paste, as though making a bechamel sauce. Make sure all the pigment becomes wet and mixed with the glue, and add glue until it becomes the consistency of single cream. Keep a lid on the pan to stop a skin forming on the surface, and set the heat on low to keep the gesso warm throughout the application process. Apply the gesso to the chosen surface, paper or board. Gesso is applied in thin layers, and on board the gesso will need between three and five layers. Paper will require a maximum of three layers unless stretched over a rigid board, as the pliable material of the paper will crack the non-pliable ground of gesso.

Each layer should become touch-dry between applications. You may need to ensure that the warm gesso does not become too thick between applications as water will evaporate, so add warm water and stir to maintain the same consistency throughout the process. It is important to try to avoid getting air bubbles into the gesso mix as this will cause pin-holes in the surface when dry. Each coat of gesso should be applied with a wide flat brush, building layers, alternately of horizontal and vertical strokes.

To get a very smooth surface, the gesso may be sanded, ideally with garnet paper or fine grade glass-paper, once it is 1 or 2 mm thick. A fine smooth surface may be the desired surface to work on with silverpoint, and may be made even smoother by using a pumice stone on the surface. An ivory-like surface can be made by polishing the surface of the gesso with a damp lint-free cloth, which effectively dissolves the top layer, filing away imperfections until the surface has developed a sheen. To work with dry pigments, the unsanded surface may already have enough tooth, but you can add up to 10% of an inert pigment, such as Barium sulphate, marble, pumice or silica, to the last couple of coats to add more tooth if desired. The additional pigment is first mixed on its own with some glue and then added to the original gesso mix, to enable the dispersal of the pigment throughout.

For most drawing practices, the gesso will not need to be sized. You can use water-based paints and inks directly on this surface.

Judy Inglis, *Carnival* (1991), charcoal on gesso prepared paper, 15 x 20 cm.

Drawing tools

Anything that makes a mark can be considered a drawing tool. In the increasingly sophisticated world of 21st century art we have become accustomed to seeing footprints in the snow, aeroplane trails in the sky, tractors ploughing fields and all manner of creating imprints or leaving a trace across a surface significant enough to be categorised as drawing.

Silverpoint

Silverpoint is one of the earliest materials used for fine drawing. Adapted from the stylus used as a writing medium for many centuries, metal-point became commonly used for drawing between the late 14th century and the early 17th century, and was used by a diverse range of artists including da Vinci, Dürer, Holbein, Rembrandt, van der Weyden and van Eyck through to Otto Dix and Picasso in the 20th century. As a medium it is highly portable, does not smudge, does not fade and captures fine and expressive detail.

The marks are made by the abrasion of the metal point on the surface to which it is applied, and the residual particles of metal are held in the granular or porous surface of the ground. This means that it needs to be applied to a hard ground. Untreated paper would be too soft, so it is prepared by stretching and priming or coating a smooth, hot-pressed drawing or watercolour paper with a water-based paint, traditionally china-white watercolour, which is made from a zinc oxide pigment bound with gum arabic. However, gum arabic does not have the strength to bind layers, which enhance the application of the silverpoint, and as a result does not allow as

full a tonal range of mark-making as a harder preparation. Alternatively, gesso panels can be prepared and provide an excellent surface for metal-point drawings as the marks can be removed or adjusted by sanding away with emery or glass paper, whereas the marks are permanent on other surfaces.

Silver, gold or platinum wire may be used and is available in a variety of thicknesses. The

Drawing in silverpoint. The delicate wrapping in tissue paper of this Amaretti biscuit is a perfect subject to explore with the delicacy of the silverpoint line.

Range of pencils 6H – 9B. This illustration demonstrates the different qualities of marks made by the different grades of pencils. Hard to soft more or less equals light to dark, amongst other qualities.

wire can be held either simply in a piece of dowel, a clutch pencil or a 'pinvise' (pin-vice) holder, which can be bought from art-suppliers. New pieces of wire need to have the sharp burr left by cutting taken away by buffing with emery paper. The marks made are fine, and the smoother the surface the finer the line will be as there will be no interruptions to the surface. The marks will tarnish to a brown colour on contact with air, unless fixed at the time of making. However, this is usually the desired effect, and most silverpoint drawings are left to tarnish.

Pencils and graphite

Pencils are probably the most widely recognised material for making drawings. They are available in a range of hardness and are relatively clean and easy to use. 'Lead' pencils are made from graphite and clay held in a wooden or other support. This material replaced the use of lead rods which were used by the Ancients to make drawings on papyrus. Although lead could be used in metal-point drawing, it is not now recommended for use because of the toxicity of lead.

Graphite was first discovered in 1564 in Borrowdale, Cumbria, England, and was initially thought to be a type of lead, only being identified as a carbon in 1779 by the Swede Carl W Scheele, and named graphite in 1789 by the German geologist Abraham G Werner – after the Greek *graphein*, to write. Graphite is softer and more brittle than lead and requires a holder to support and protect the material. Crude versions of graphite pencils were first made in the 17th century. The graphite from Borrowdale was pure enough to use without modification. It was cut into chunks known as

marking stones and wrapped with string, which was unwound as the core wore away. These implements became known as pencils, taken from the Latin name peniculus meaning 'little tail', given to brushes which also consisted of a fine tip held by a wooden handle, and were used to apply an existing medium, ink.

However, not all graphite was as strong as that from the Borrowdale seam and needed to be modified for use as a drawing medium. In 1794, Nicolas-Jacques Conté invented a process to mix graphite with clay and water to make fine rods for pencils, which were designed to be encased in wood. The process of making the graphite mixture involves milling the graphite and clay together into a fine powder, to which water is added. The water is then pressed out and the resulting sludge left to air-dry. This is ground to a powder, water added to make a soft paste and then extruded through fine metal tubes to make the pencil lengths, and dried and heated to temperatures of c 1000C° to make them hard and smooth. These are then encased in the wooden supports, made from a range of woods, most commonly incense cedar. Until the 1890s, pencils were left unpainted to show the grain of the wood the lead was encased in, but later were usually painted. For example, pencils made with very high-quality Asian graphite, discovered in the mid-1800s by Jean-Pierre Alibert on the Russian-Chinese border, were painted yellow to signify the source of the graphite used. In the early 19th century, Joseph Hardmuth discovered that the greater the amount of clay used in the process the harder the pencil point, which led to the development of pencils being graded by hardness.

Sarah Woodfine, *Untitled No 4* (2000), pencil
This drawing is inspired by Norwegian stave churches, and floats as a fragment within a pool of dark. The drawing is highly rendered and heavily stylised, using pencils to achieve a uniform depth of tone and detail.

Pencils are available in a range of grades from 9H to 9B. The hardest pencil is the highest number coded H, the abbreviation of hard; the softest pencil, the highest number, coded B, abbreviated from black. The hardness of pencils is due to the incremental addition of clay to the mixture; the more clay that is added, the harder the pencil. F for Firm is sometimes used as a code, and corresponds to a hardness between H and HB. The softest pencils contain little or no clay.

The rod of graphite, which consists of fine flat plates or flakes, has a slippery or greasy feel. The dragging of the pencil across the surface of the paper forces the particles of graphite into the interstices of the paper, and through the pressure of mark-making causes the flat plates or particles to sit level with the surface of the paper. This action 'polishes' the flakes, giving the mark a distinctive sheen.

Mechanical pencils were first introduced in 1822, and the spring-loaded mechanical pencil was patented in 1877. These mechanical pencils advance a fine lead incrementally and avoid the need to sharpen it. The leads used are manufactured in the same way as clay, and may be additionally bonded with polymers to strengthen them. They are available in the reduced range of grades from 4H to 2B, as they are too fragile in either harder or softer grades. The leads are available in varying widths – 0.3 mm, 0.5 mm, 0.7 mm and 0.9 mm – and make an even mark as the graphite rods can move, and roll, within the holder as the pencil is dragged across the surface of the paper.

Graphite sticks

Graphite is also available in sticks, fatter than pencils and without any wooden casing, in a range of thicknesses; these make correspondingly wider marks. The scale of hardness used for pencils is also used for graphite sticks, indicating to the artist the quality of mark that can be made. There is also a soluble pencil, often known as an aquarelle pencil; marks made with it can be adjusted with water or spit.

Graphite is also available in loose powder form and may be used to add soft marks with a brush or rag, and with water to emulate wet marks with broad brushes, which are left flush on the surface of the paper as dry marks with a silvery sheen. It may also be used with fixatives to fix a seemingly 'liquid' graphite mark, by suspending or sealing the flakes of graphite in the fixative solution.

Charcoal

Charcoal is made from charred willow wood, burned under controlled circumstances in kilns. Charcoal is available in different widths, defined by the width and size of the willow burned to make the product. It is available in fine and medium sketching charcoal, and the wider or mixed scenic charcoal, and extra large sticks.

Wood charcoal makes a warm mark. Cooler blueish marks can be made with a product known as Siberian charcoal, although this is not easily available. It is made from charred bones by a similar process. Charcoal was traditionally produced through slowly burning the carefully selected willow sticks in pits in the ground, covered with earth, and is still made by this

Varvara Shavrova, *Inscriptions 33* (2000), graphite on paper, 56 x 76 cm *Graphite is here used both as a dry medium and a wet medium, to suggest the imprint or inscription of one thing upon another.*

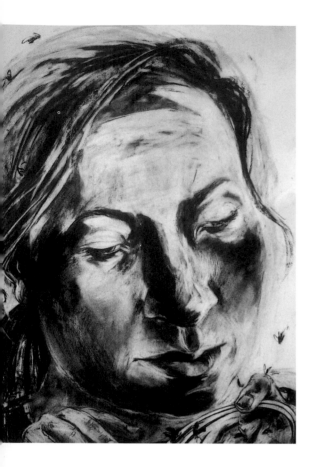

Anita Taylor, *Examination* (1993), charcoal on paper, 76 x 56 cm

process in the Forest of Dean in Gloucestershire. It is commercially produced from specially grown crops of year-old willow rods, or withy sticks, which are boiled for around ten hours to soften the bark. The bark is then removed by machine. These processed rods are then cut to regular lengths, which become the final charcoal sticks. They are graded thin, medium and thick, from the various parts of the willow rods, bundled and packed tightly in air-tight tins and fired in a kiln for ten hours. To make the extra large sticks of charcoal, willow rods are taken from two- to three-year-old willows.

Charcoal pencils are also available, and are made from either charcoal or compressed charcoal in a wooden casing. These offer a relatively strong and clean way to handle the material. They can also be sharpened to provide a fine tip for delicate work. As with graphite pencils, it is important not to drop them as the material core will shatter or fracture making the pencil impossible to use effectively. All pencils may be sharpened with a craft knife, sharpener or emery paper.

Carbon pencils are made from compressed lamp black pigment, which is pure carbon and is a light, fluffy powder made from the soot collected from the burning of oil. It has been in use since prehistoric times. The marks made from this material are very dense and it may be quite difficult to remove speculative marks when you want to adjust or remake the drawing.

Compressed charcoal is made by mixing ground charcoal powder with a binding agent, producing short break-resistant sticks which may be either round or square. The amount of binder used defines the softness of the sticks, and they are graded similarly to pencils with HB, 2B, 3B and 4B grades available. This machine method of compression enables regular marks to be made with the sticks, which also leave a darker more emphatic mark than that of regular charcoal.

RIGHT: *Drawings made with compressed and willow charcoal on rough paper(top), Not paper (centre) and Hot-pressed paper (bottom).*

Changing the image

Paper does not need to be prepared for these materials, although a gelatin-sized paper will allow heavier marks to be made and more manipulation of the marks. The marks are lightfast and stable, although some may need to be fixed using spray fixatives to preserve the richness of the marks and make the powdery residue stick to the surface of the paper. Until the drawing is fixed, it is possible to manipulate the marks you have made by removing them with your hand, rags or erasers. Hard white plastic erasers are most effective for removing marks and getting back to the whiteness of the paper, and a range of erasers can be used to make various marks. These include putty rubbers, which can be softened and manipulated to take away charcoal sensitively and delicately.

The above media are basically black or tonal in their range, and most are made from different carbons.

When drawing remember:

Trees become charcoal, paper may come from trees, and carbon is a main constituent within our physical make-up. Out of these constituents you can either make a pile of dust or a diamond, depending on what pressure you bring to bear on it.

Paul Thomas, *Hyena* (2000), charcoal and Conté crayon on paper, 122 x 150 cm

Coloured materials

Pigment is made from the powdered residue of a vast array of diverse materials, ranging from simple earth, with browns and ochres, crushed beetles for carmine red, and precious lapis lazuli for exquisite blues. In Duccio's workshop in the 13th century, one had to specify if the blue used in the painting was to be true lapis lazuli or an inferior substitute. Only the very wealthy could afford such open displays of affluence.

Pastels

Pastels are available either as chalk pastels or oil pastels. They are made from pigments, both coloured and tonal, which are bound together to form short sticks for use directly on paper.

Chalk pastels are made with dry pigments and a binder, usually a weak gum. The strength of the pigment is moderated by adding a mixture of precipitated chalk and whiting. The pigments used in pastels should be permanent and non-toxic; the material is powdery and may be inhaled or absorbed through the skin. The waxed paper wrapped around the pastel affords some protection to the skin from the loose particles of pigment. The deeper tints of pastel are made from the most intense pigments, and the paler tints have more chalk and whiting in the mixture. The surface selected for working on with chalk pastel needs to have a good tooth, as the particles of pigment applied to the surface are much richer if they accumulate in the ridges or surface of the paper. You can prepare your paper with a toothed acrylic primer or a gesso surface, which would hold a dense amount of pigment. You can tint the primer with coloured acrylic paint to provide

a coloured ground to work on. The opaque nature of the marks made with pastels means that a white paper is not essential and a coloured ground may help unify the drawing. Alternatively, you can tint the paper either by stretching it and applying a watercolour or acrylic wash, or by applying dry pigment to the paper with a small stiff brush so that it adheres to the surface.

Chalk pencils are chalk pastels in a wooden casing. These offer a cleaner way to work with pastel, and the point can be sharpened for detailed drawing.

Oil pastels were originally made by mixing the pigments with a slow drying oil, such as poppy oil, and mastic resin dissolved in turpentine. Wax was then added to this mixture to enable it to be shaped into sticks. As the turpentine evaporated, the crayons hardened, producing a high-quality pastel with a limited shelf-life. The current version of oil pastels consists primarily of pigments dissolved with fossil wax, and with some mineral oil added to enhance shelf-life. They are soluble with

Chalk pastels on coloured khadi paper and watercolour paper

turpentine or white spirit, and can also be manipulated with heat from a hairdryer or infra-red lamp, a little like encaustic paint. The marks made with oil pastel are difficult to remove and should be used in a cumulative drawing process. They may be used on gelatin-sized paper without preparation, as the size is sufficient to resist the absorption of the small amount of oil into the paper fibres.

You can make all pastels yourself, although the quality and range available on the market is very extensive and will satisfy most artists. The advantage of making pastels is that you know exactly what the constituent ingredients are, the density of pigment can be adjusted and you can make batch quantities of particular colours you need.

Crayons

Conté crayons are named after their developer, Nicolas-Jacques Conté, the inventor of the pencil. They were originally a mixture of graphite and clay formed into hard drawing sticks, a similar process to that used by Conté to make pencils. They are now made from an aluminium oxide (alumina chalk) base. The white crayons are pure alumina chalk; the blacks and greys are carbon (soot black) and alumina chalk. The reddish browns or sanguines are made with ferric oxide (rust) and alumina chalk, and provide a warm-toned drawing medium in several shades. The use of pigment gives an essentially different tonal quality to that of graphite or charcoal. A range of coloured Conté crayons is now also available, using a range of coloured pigments to give a stick with the consistency of a graphite stick and the appearance of a hard pastel.

Coloured pencils

Coloured pencils, like the pastel pencil, were originally developed for use by illustrators and graphic artists and are available in four varieties: soft pastel pencils, and non-soluble, water-soluble and turpentine soluble pencils. The coloured pigments are bound with chalk, clay or wax in a synthetic resin to form the 'lead' held in a wooden casing. They offer the control of drawing with graphite or carbon pencils, and have a full colour range.

Fluid media

Fluid media need to be applied to stretched papers, otherwise the areas that become wet with the ink or paint will stretch unevenly and buckle. If using gesso panels, you will need to size this to resist the absorption of the liquid, leaving the pigment unbound on the surface of the drawing.

Ink for drawing and writing was invented in both China and Egypt around 2500 BC. The inks were generally the same as those produced now, a mixture of carbon and binders, which could be diluted with water as needed. The Romans later introduced sepia to make ink, made from the dark liquid found in the 'ink sacs' of cuttlefish or squid, and which resulted in the warm brown ink used by artists, including Rembrandt, in more recent times.

Emma Talbot, *Untitled* (2003), coloured pencils on paper, 17.8 x 12.7 cm *The images are part of a sequence of drawings, which refer to the mediated images of advertising and fashion. The female subjects fit into an apparently seductive and incident-free world/surface. The coloured pencils allow for speed of notation. Although often difficult to use, they are particularly suited to these images and the subject they deal with, as they have a fresh and attractive appeal.*

Indian ink is generally made from lamp-black pigment bound with a shellac and borax, which produces waterproof marks. It is also made with an acrylic binder, which means that the marks can be washed away once dry. Both kinds can be diluted with water while liquid.

Chinese or Japanese inks are made similarly, but are available in solid stick form. These sticks are rubbed on special stone ink-blocks and are diluted and mixed with water to the desired consistency.

Coloured inks are either bound with acrylic or shellac, acrylic being the most transparent and flexible binding agent. However, most coloured inks are made with dyes, which are fugitive and designed to be used on work which is to be reproduced, rather than for the preservation of the work itself. Coloured inks are now being made with lightfast pigments and are known as liquid acrylic inks. However, coloured ink-sticks are usually made with dye rather than pigment, and therefore are not lightfast.

Applying fluid media

Pens, nibs, quills and brushes are the usual tools to use with ink, and define the quality and kind of marks it is possible to make. Brushes used to apply ink are usually made of sable, squirrel, badger hair or synthetic nylon fibres which emulate the qualities of the natural hair brushes. They are available in a range of widths and lengths of brush-head and handle, all of which affect the mark-making possible with the material. Brushes are loaded with ink or paint and leave behind the residual mark or trace of the brush. Traditional calligraphy brushes may also be used. Steel nibs and holders are widely available and offer a wide range of mark-

making possibilities. They are used to dip into ink and hold a small reservoir of ink in the nib. Quills, reeds and bamboo may also be used to make pens. Goose, turkey and swan feathers make excellent quills as the fibre is strong and resilient, and can be cut to different nib widths and lengths. Reed and bamboo is similarly strong and can be cut accordingly, and re-cut as the nib wears away with use.

Fibre-tip pens and markers are available everywhere, and can be successfully used to draw with. The tip is made of nylon filaments, however, and they are not made with lightfast ink so will degenerate quickly on exposure to light. Nor are they acid-free.

Paint

Paint provides another method of adding colour to drawings. Importantly, as paint is a wet medium, remember to stretch the paper you are using or to size gesso panels, or prepare a canvas to work on. The question of whether the piece of work remains a drawing once paint is introduced is a contentious one, and would depend on how colour through this medium is added to the piece. Brushes are the usual implement used to apply paint, and are available in a range of designs to apply different paints and to make different marks.

Watercolour, gouache and acrylic colours may be used on un-primed papers; the addition of oil paint, or oil paint sticks, requires the preparation of the surface by priming or sizing to prevent the oil binder within the paint seeping into the paper. This preparation would mean that

RIGHT: *Drawings made with felt tip pens on rough paper(top), Not paper (centre) and Hot-pressed paper (bottom).*

the longevity and preservation of the drawings is enhanced for posterity. However, some artists use oils and oil paints to make marks or stains on the paper, preferring the quality of the mark made in the shorter term, which will often mean at least a few decades, but not centuries.

Erasers

Erasers and rags can be employed to make marks in addition to removing or negating them. If you wish to make marks by removing materials, you must ensure that the medium you have chosen can take this amount of manipulation. Materials such as charcoal, graphite and pencil are the most pliant in this respect. Soft fresh bread, rolled into a usable shape, constituted the first kind of eraser. By the mid-18th century, natural rubber began to be used, although most rubbers are now made of plastic. Generally, the harder the white plastic rubber, the finer, more effective and incisive the removal of marks can be. Putty rubbers are highly effective with charcoal and soft pastels, and can be kneaded to make them more pliant and sensitive, and to make a clean surface to remove marks. Dry cleaning powders or draft cleaning pads (sometimes known as a 'mouse') are made of finely crumbled vinyl eraser particles, which in the loose form are sprinkled onto the surface and rolled or rubbed into it to remove faint marks, including the general greyness sustained from working on a surface with graphite, and also the residual skin oils that transfer to the paper while working. The pads contain these fine particles in a stockinette pouch, which can then be gently smoothed over the surface to lift general griminess and gently clean the surface of the paper.

Other tools

Blending tools made of pointed, compressed paper cylinders may be used to delicately blend areas of a drawing made in charcoal or pastel, which are too small for a finger, rag or rubber to reach. The effect is to soften an area of tone.

Cutting tools and knives may also be employed to make marks in drawings. A number of contemporary artists use incisions, prick the paper and shape paper to enhance the reading of the image or to make marks like those of a sharp pencil.

Collage may also be an important device to be employed in drawing. It may be used as a form in itself but can be used to re-emphasise or restate elements of drawing. The Matisse cut-outs, for instance, use drawing to manipulate a surface and design and also to go beyond the edges of the standardised size and format of available papers. Effects such as transparency and overlay may also be used through this system of working.

RIGHT: *Drawings made with coloured inks on rough paper(top), Not paper (centre) and Hot-pressed paper (bottom).*

Drawing equipment

A number of pieces of equipment are designed to help with drawing, either to align the picture plane with the subject, to help with measurement and perspective, or to help with tracing or copying through projection. These instruments have been in use for centuries as aids to understanding, measuring and plotting drawings and designs.

The drawing course in the next section explores the notion of fixed-point perspective and multiple perspectives. The fixed-point perspective is dependent on maintaining a single view, which is a synthetic reality, as human beings do not see a fixed horizon line or vanishing point from a single viewpoint. This is the viewpoint that the camera lens demonstrates now. In the late Middle Ages and Renaissance periods, mechanical aids were devised using a peep-hole, which solidly fixed the single eye to a fixed view. Drawings of these machines by Dürer show a low table supporting a pane of glass set in a frame at one end and a stake at the other end to support the peep-hole. The artist sits, looking through the peep-hole with one eye at the subject placed or seated beyond the glass pane. The outline of the subject is then traced onto the glass with a greasy crayon, and the artist takes a further tracing from the glass onto paper, either to be transferred as a basis of a painting or as the basis of a drawing to be developed. This type of machine was in use by 1450 in Italy. A more complicated machine, illustrated, involved cords, weights and a pulley to enable the artist to chart a set of points directly on the paper without the need for further retracing.

The camera obscura

The camera obscura is another machine used for the tracing of 'accurate perspectives'. First described by Daniele Barbaro in 1568, the device was also available as a portable device for drawing landscapes, and was described by Robert Hooke in 1668. The principle of the

Albrecht Dürer, *Drawing Machine* (1525), engraving.

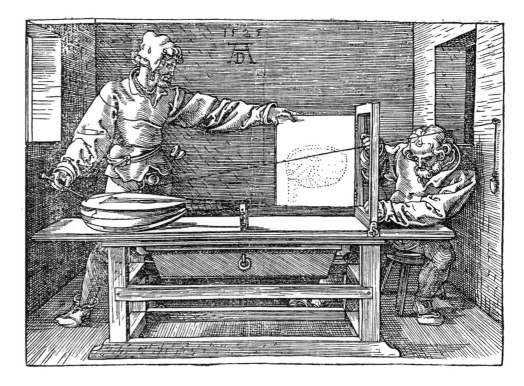

camera obscura, derived from the Latin for 'dark chamber', is a natural phenomenon harnessed as a device for artists. The phenomenon was recorded in the writings of Aristotle in the 4th century BC. The device consists of a pin-hole, or a convex lens, opening into a dark box. Through this aperture an illuminated image of what is external and facing the box is projected, inverted, onto the internal wall opposite the subject, and by placing a sheet of paper on the vertical wall of the box, the projection can then be traced by the artist. By having the aperture in the roof of the box, and using a mirror to deflect the image, the reflected image can be projected onto the floor of the box without inversion, allowing the artist to trace the image the right way round. This device was widely used by artists, and was also made on a larger scale, in the 18th century, for enlightenment and entertainment, in the form of a small round building, with a rotating angled mirror at the apex of the roof, resulting in the projection of an image of the landscape onto a horizontal surface inside. The principle of the camera obscura is the same as that of the familiar camera today, which simply fixes the image onto a film negative or positive, or into digital memory, to reproduce the mechanical single-point viewpoint.

The camera lucida is a small portable instrument invented by William Hyde Wollaston in 1806. The name means 'bright chamber', and as it implies this instrument could be used anywhere without the darkened space of the camera obscura. The instrument consisted of a prism with two reflecting surfaces at 135°, which conveyed an image of the scene at right angles to the viewer's eye, placed above it. The viewer places his eye, guided by a viewing aperture, so that the image and the surface to be drawn on can be seen at the same time. The device also has two auxiliary lenses, hinged to allow one to be positioned beneath the prism and one in front to improve focus.

Photography and projection

Video and photography may be employed to record 'found' drawings, images or marks found on surfaces or in the landscape, and they may also be used to record the movement of light. The process of recording the light allows the movement of the hand or wand to be traced and to be recorded as a still image. These stills from a video recording, by Katayoun Pasban Dowlatshahi, may also be regarded as drawing with a camera. The images are made by recording light, refracted on pieces of Perspex, captured with a digital video camera. These are then inverted and describe shadows reminiscent of Turner landscapes and the use of fluid mark-making.

Visualisers and overhead projectors enable artists to project images which can be easily manipulated to fit the size of the drawing or other art work to secure an initial tracing of the subject, prior to developing it as an image.

Katayoun Pasban Dowlatshahi, *Untitled* (2003), digital video stills *These images are of 'captured' light, reflected onto a piece of acetate, and recorded with a video camera. The image is then reversed to make the light into shadow and create a moving drawing, which is liquid in sensation and records the movement of light across a surface at a particular moment in time.*

Computers

Computer programmes allow artists to copy, manipulate and plot information from mechanically derived sources. Developments within this technology are moving so fast that there are even programmes now which can help you draw like (or suggest that you can reproduce the mark-making techniques of) van Gogh or Seurat. Printing inks are achieving lightfast standards that will revolutionise the way we view reproductions, or reproductive methods of making art. A new generation of artists is being trained in art schools in the use of computer programmes which appropriate imagery. Students use these programmes to represent a naturalistic world without needing to be familiar with all the languages and derivations of art.

Tracing papers

Tracing papers are often used in planning and preparation. The paper is made of either a semi-transparent paper or plastic material, and is the most straightforward means of copying or transferring a drawing. Drawings may be transferred when they are preliminary drawings for paintings or an image needs to be produced individually by hand. A cartoon for a mural or fresco is transferred to the wall by a tracing wheel – which is a spiked wheel with a wooden handle. This perforates the paper while closely following the linear design of the drawing. The cartoon is then fixed to the wall and the perforated lines are 'pounced', by tapping a small pigment-filled muslin bag over them. The fine pigment powder, usually lamp black, powdered charcoal or an umber earth pigment, leaves a trace of the drawing on the wall to be painted or plastered. The original cartoon or design may be traced and the tracing pounced to keep the original drawing intact. Another method of transferring a drawing to a painting is 'squaring up'. The method is to draw a grid of equally proportioned squares across the surface of the drawing, and to draw the same grid on the canvas to be painted, and then to copy freehand the information found in each square.

Daniel Young, *Staverton* (2002), computer-generated print *The artist works with a 'pen' and electronic drawing pad to make this kind of drawing, as the traditional mouse does not have the control needed. The potential of this medium to create and present variations on an original image or theme is almost limitless.*

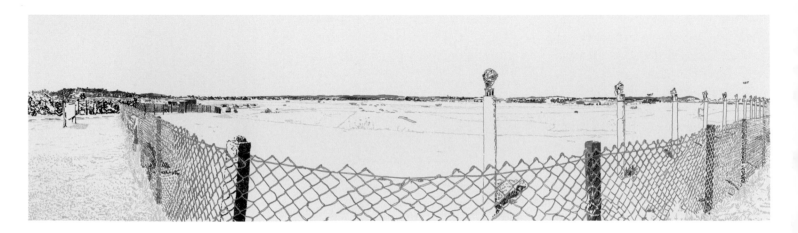

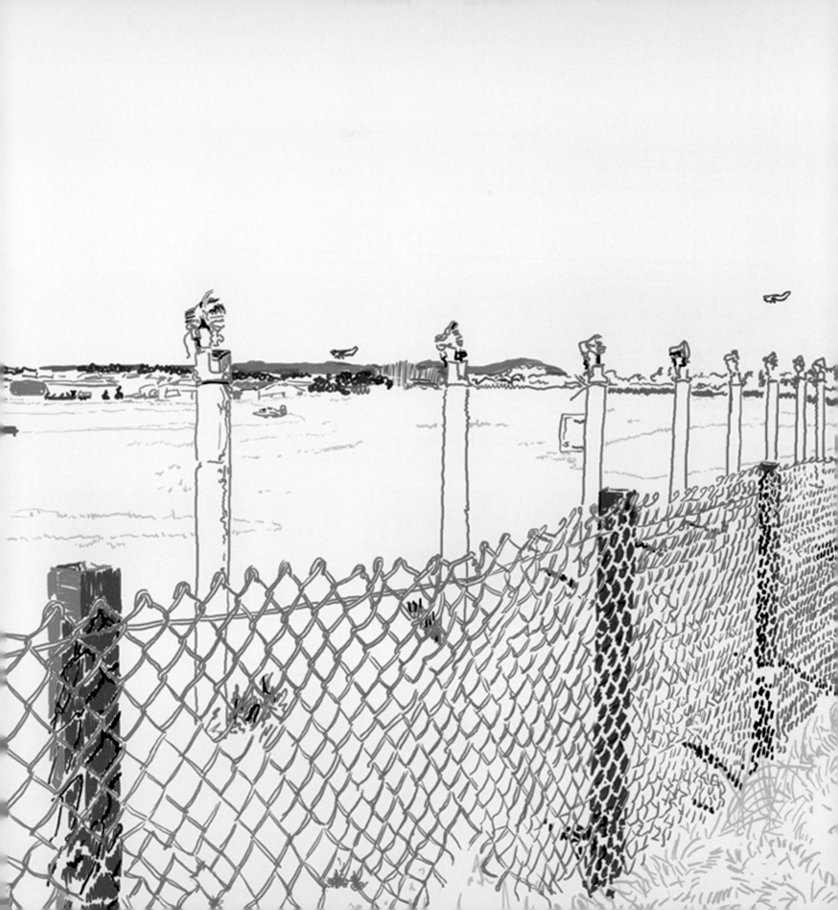

Easels

Easels are often overlooked as significant pieces of equipment. However, they are designed not only to support a drawing board or canvas, but to enable artists to position the board for their own particular needs. The radial easel is adjustable in height, so artists can relate their drawing board to their eye level, and is free-standing so that the board is on the same plane as the artist's plane of vision. The radial easel may also be tilted so artists can avoid rubbing their hand against the surface of the drawing and smudging it. This also means that the plane of the drawing board may be matched to the artist's plane of vision if they are looking down on the subject they are working from. This is particularly appropriate to dry media.

More substantial studio easels are designed primarily for painting. These allow the painting or drawing board to replicate the plane of vision, but may not be tilted from the vertical. They are designed to be used standing in a fixed position to help keep a fixed plane of vision, and to take significantly larger boards or canvases. Sketching easels are lightweight easels designed for carrying, and usually support small boards only. 'Donkeys' enable the artist to be seated as though sitting astride an animal, and to support their drawing boards with a lower angle of vision.

Drawing boards

Drawing boards may be made simply by cutting a piece of MDF to the desired size, which should be a few centimetres larger than the size of paper that will be used on it. Paper can then be held securely on the board by masking tape, which should peel away without taking

Cheryl Brooks, *After Crivelli* (2001), collage, paint and gold leaf, 91 x 183 cm *In this meticulous collage, careful selection allows the artist to modulate existing fragmented images in tone and colour, and to reconstitute them in a complex relationship with an already existing image taken from an Old Master painting. In doing so, the artist re-evaluates the older work with exciting juxtapositions of found images from the contemporary world.*

the surface of the paper with it, by pins or by special drawing board clips if no marks are to be left on the paper at the end of the drawing process. What is most important, however, is to fix the paper to the board securely for the duration of the drawing.

Gum-strip is used for stretching paper. This is a brown tape which is damped prior to application to the damped paper. The tape is applied to the whole of the edge of the paper to prevent it from curling with the damp, and once the drawing is complete it is cut away. This of course means that you lose the edges of the paper.

Means of preservation

Protecting and preserving drawings is an important consideration for the artist. Most drawings, made in carbon or dry media, are not permanent, and marks may be smudged, as the dust particles are unsettled by the movement of the paper surface. It is impossible to move or store pastel or charcoal drawings without some disturbance to the surface marks.

Fixatives may be used, although this process is not always necessary and can change the nature of the marks made, by darkening the tonal value or by losing the 'dustiness' and seductive quality of the marks themselves. However, if a drawing is to be moved a lot once framed, or not framed to protect the surface of the drawing, then the use of fixatives is a good idea.

Fixatives may also be used to 'fix' a layer of a drawing before adding subsequent layers, and as such are a useful tool in the making process. Fixatives are available in proprietary brands, usually in an aerosol spray, which disperses or atomises the acrylic resin and

lacquer thinner. Always use fixatives in a well ventilated space, or outside, and use a mask to protect yourself from inhaling the spray.

A common practice for pastel artists is to fix the drawings from the back of the paper, enabling the fixative to soak through the paper and grip the underside of the dry chalky marks, rather than soaking the top surface of the marks and changing the nature of the mark or colour.

Storing drawings in a plan-chest or portfolio is the best method, as this allows the paper to remain flat, thus not affecting the relationship of the marks held in the surface tooth of the paper. The drawings can be protected with a single sheet of acid-free tissue paper between each individual sheet of paper. Acid-free tissue is only available in white and needs to be acid-free to prevent any impurities, stains or marks being transferred to the original drawing. If drawings have a particularly sensitive or textured surface, you may need to consider using mounts or strips of acid-free mount board to form a surround to separate the papers and the drawing more substantially.

The framing of drawings is essentially a matter of ensuring protection of the surface, and should be done with acid-free mounting products. The surface of the drawing should be clear of the glass itself. With heavy paper this may mean using a deep mount or museum-board window, and may require spacers to be built into the framing design to prevent the surface of the drawing coming into contact with another surface. Another consideration is whether the edges of the paper are visible or not. If the edges of a hand-made paper are important to the quality of the drawing, they should be visible once the work is mounted.

Michael Shaw, *Light Drawing IV* (2003) *This image is life-size and photographically records moving light, used by the artist to convey the idea that a continuous line in three dimensions can suggest a three-dimensional form.*

Claude Heath, *Pith (peeling oranges),* acrylic ink, 50 x 80.5cm.*The artist wanted to draw a subject that was changing and chose to work with oranges, peeling them and drawing them at the same time, aiming to record the experience of touch, neither looking at the orange or the drawing. The drawings use a system of different colours for different areas of the orange to describe how near or far they felt.*

OBJECTIVE DRAWING

'I simply must produce after nature - sketches,

pictures, if I were to do any, would be merely

constructions after nature, based on methods,

sensations and developments suggested by the

model, but I always say the same thing.'

Cézanne, to his son Paul, 1906

Measuring the world

Drawing has long been used as a means of recording and describing the world around us. Mapping and measurement of the world is a fundamental aspect of this process. The following drawing course has been designed to simplify and emphasise the underlying ideas and processes involved in recording from observation. This is essentially a Western concept. It uses vanishing-point perspective, and was substantially developed in the Renaissance and documented by Alberti (1404–72), and further developed and explored by Leonardo da Vinci (1452–1519).

Western perspective is essentially a fixed-point perspective, and this is dependent on a single viewpoint. It is a means of suggesting on a two-dimensional surface the effects of three-dimensional space. It is an artificial system developed for effect, and therefore has rules and concepts which generations of artists have followed. These rules apply principles that have been developed from geometry, and could not be strictly applied to the pictorial construction of perspective, as the eye and the experience of looking do not strictly conform to the single point of a mechanical mathematical concept. The drawing course that follows will demonstrate how the artist needs to make judgments and compensations for this as the drawing progresses from the initial stages when geometric principles can be easily applied.

Subjects, objects and space are defined by finding comparable points with which to evaluate measurements and locate the relationships of reference points to objects, and subjects in space. This involves the selection of reference points, plotting them, and correlating them with the subject. This concept of measuring uses the format of the paper as a frame and works within the edges of the paper, essentially the traditional viewpoint of a painter.

The frame of a rectangle of paper gives a frame of reference with which to judge, measure and locate the relationships of what we see. The scale of what is depicted within this frame informs the viewer about the relationship in space of the artist to the subject of the picture.

These drawings sit firmly in the tradition of a neutral language, which affirms the notion of the observer-artist as a neutral recorder of factual information. This exploration of the visual field is evident in the work of 20th-century artists such as Euan Uglow and William Coldstream, and was taken to its logical extreme by Alberto Giacommetti, who took the recording and measurement of co-ordinates of subject and space to the outer edges of the perceptual field of vision.

Importantly, the course introduces the key terminology used when making observational drawing, and an understanding of how these terms and concepts are applied to the principles needed to draw from objects, figures, and space.

Leonardo da Vinci, *Vesuvian Man* (c 1485–90).

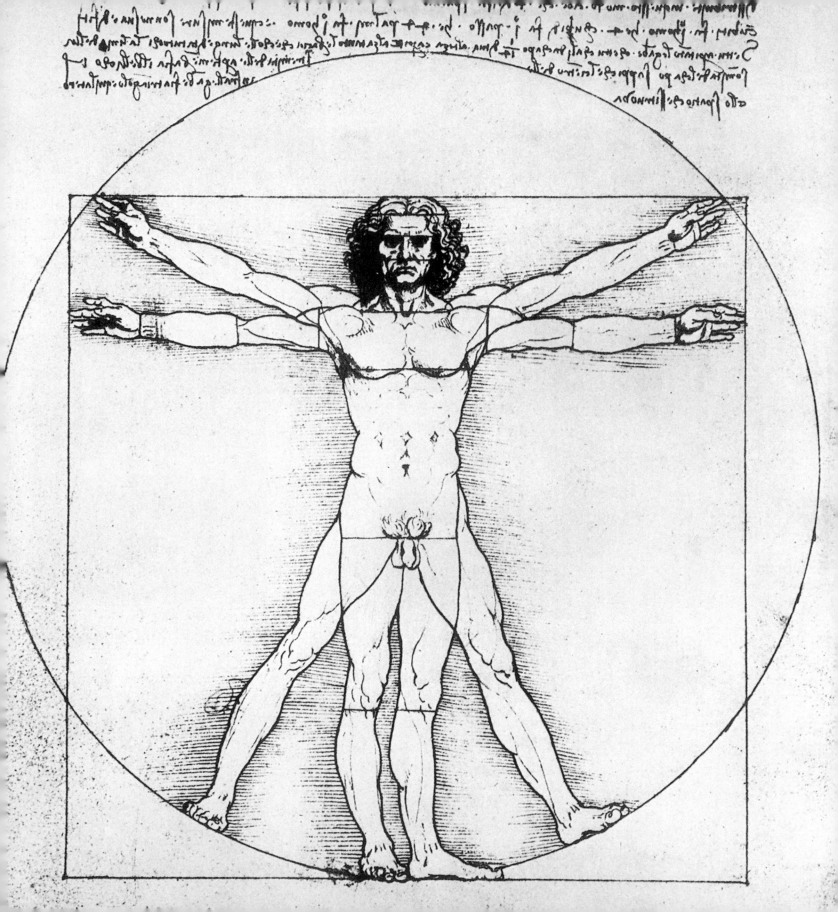

Measurement course

Principles at work

How do we measure the world? Think of a map with the co-ordinate points and comparable measurements using a grid. The grid essentially enables us to plot comparable points and make relationships between these co-ordinates to communicate information. The use of format, point relationships and orientation to measure the world remain the same as they have been for hundreds of years. At its most basic, we can orientate ourselves in the world in relation to objects that are above, below, to the right or to the left.

Hold your pencil vertically, and at arm's length, and use it as a tool to find a convenient fixed unit of measurement for the subject being drawn. For example, when drawing a standing figure, find the size of the head and use this as the unit of measurement. The size of the figure and of the drawing can then be quickly established.

The course will explore the essential concepts of the picture plane, the cone or field of vision, eye level, centre of vision, parallel perspective, angle of vision and measurement of points, straight lines and curves. It also covers point relationships, linear frameworks, line, area, shape, size and scale, and measuring using fixed points and grids.

The easel you are working on should be totally vertical (at 90° to the floor plane). You will need to position the easel and board so that you can see as much of the drawing and the subject as possible when standing at arm's length. The reason for this is that you will need to use your body as a 'measuring machine'. Fix a point on the floor for your feet when you are in this position. You will need to measure with a straight-edged implement - you may use a ruler or the edge of your pencil.

For this exercise we will make the drawing of what you see in front of you 'sight-sized'. Now determine your eye level. This is the level of your eyes, and the level from which you view the world. If you were to draw an imaginary horizontal line straight ahead from your eyes, this would tell you where your eye level is in relationship to what you are to draw.

1 | *This simple exercise involves drawing a sheet of black sugar paper with pins placed in it. As you put the sugar paper on the wall, you will already have a set of relationships that need to be established on your drawing before you go much further.*

2 | In your mind, choose a point on the paper as if you were staring straight ahead, looking neither up nor down. Ensure you are vertical, the sugar paper is vertical and at right-angles to you. Make a single mark. This mark is at your eye level. The mark should also be in the centre of the paper, equidistant from the vertical sides. A vertical line will give you an axis that marks the centre of vision. You can form a cross now and this establishes the eye level and centre of vision. Where the two meet you have a point that will anchor your drawing. This will enable you to plot the points and are essential co-ordinates to recognise for all measured drawings from observation.

3 | The first pin is placed to the left of the centre of vision and above the eye level. How far to the left and how far above can be measured by creating a grid reference. Now plot the distance between the left edge of the sugar paper and the pin. Using our anchor point, we can determine that the pin is less than halfway between the anchor point and the top of the sugar paper. Where the 'how far across?' line, and the 'how far up?' line cross, make a mark – this is the location of the pin.

4 | Now put the second pin in position. This presents the same location problem. How far across and how far down is it from the anchor points?

5 | Add the third pin. This should be a little easier to locate, using the same method. We now also have some other co-ordinates, supplied by the other pins, to help us check for accuracy.

6 | A straight line has been added to the sugar paper. Draw this by plotting where the end-points are and joining them up.

7 | Now the illustration shows a straight line and a curve.
A curve presents a bigger problem to locate by our previous method. Start with the location of the two end-points, and then measure several 'points' along the curve and plot these in the same way as before. Then join these up to form the curve on your drawing.

8 | Now more curves are added. Remember the principles at work and concentrate. Imagine how complex it is to draw a figure in this way.

9 | Even quite complex curves can be plotted. Gradually the drawing becomes an accurate record of where everything in the subject is located, in relation to your eye level and centre of vision.

10 | *As you move your head down, you appear to change your angle of vision. In fact you change your plane of vision. You need to re-establish co-ordinates to get another anchor point. Remember your centre of vision has not changed (the vertical one). The horizontal one is also straight ahead, but it is a line projecting horizontally out from what you are looking at. Imagine this point imposed on what it is you are about to draw. You are now drawing a new plane but the rules stay the same.*

11 | *The marks now introduced to the sheet of black sugar paper need to be located, using the same process as before.*

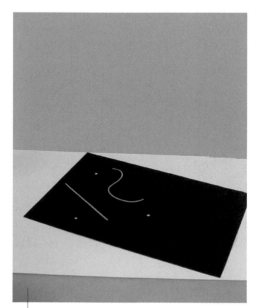

Getting things in proportion and orientated correctly is a major cornerstone in drawing. In our day-to-day lives we take a lot of this information for granted. If you are confronted with a door that is too small to get through, you know this well enough before you try to go through it. You have quickly assessed the height to width in relation to your own body size.

Now things get more complicated. So far you have looked straight ahead. Now imagine a cone projecting from your eyes. This gives you vision, without moving your head, for about 45° around the anchor point before things get blurred. So how do you draw something on the floor?

12 | *The straight line also presents the same problem as before. Locate the two end points and join them up. These curves are more complex to locate than the previous ones.*

13 *Retaining the same position in relation to the wall and the floor plane, you will find that you are too close to see the whole of the subject (the pieces of black sugar paper) from where you are standing. You will need to step back in order to 'see' and 'measure' the paper on the floor and the paper on the wall. You need to see the flat wall and the floor plane without moving your head in order to measure.*

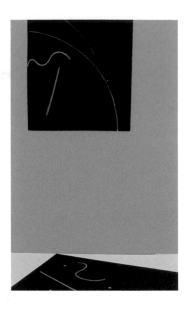

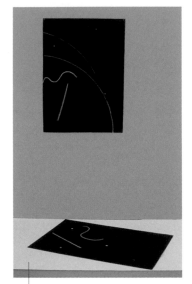

14 *The same principle applies as in the first set of drawings. Once you have established your eye level and centre of vision, you can step back and encompass both planes with a good degree of accuracy.*

The problem with this type of drawing is that if you want to combine things above and below the eye level with great accuracy, you have to move back constantly to give yourself this 45° cone of vision. The farther back you go, the less you can see, so it is a matter of diminishing returns. What mostly happens is that a compromise is reached so reasonable accuracy can be maintained, and you can still see the subject clearly.

Most artists will use this 'system of looking' to gauge proportion when drawing from life. However, they employ this system conceptually and generally do not leave the traces (of the plotting) behind.

Now we have established how to draw something directly ahead of us on the wall and, separately, something on the floor plane. How do we put these two elements together?

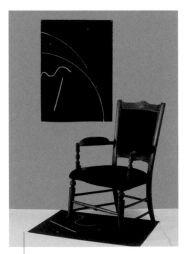

15 *Adding a chair creates an object in space rather than the flat pattern and the single plane. You need to keep concentrating and plot these points, as before, to locate the chair in space.*

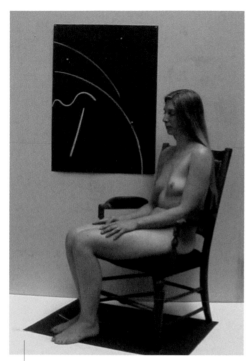

16 *The addition of a model at this stage allows you, using the same method, to create a beautifully complex map of where all the points are, and to know that you have plotted them with accuracy and established proportion.*

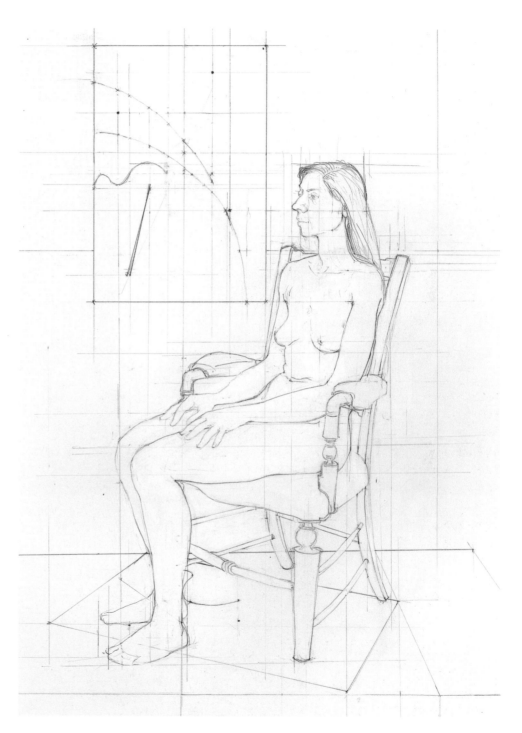

Describing light with tone

The course has so far demonstrated a linear method of drawing, the system which locates the point relationships and the relationships of the edges of objects and subjects in space, described by a dark line. The quality and modulation of the darkness of the line is not important, only the shape defined by the line, and a linear framework to hold the drawing together.

1 | *Areas are mapped out. These marks are made on a rough piece of paper that does not allow for a clear linear framework to be used.*

2 | *As tone is applied, it is clear that Seurat was interested in the tree trunk being light against the ground and then dark against the river and sky.*

3 | *As the tone of the river approaches the upper part of the trunk and the man, it gets lighter, and, as the grass approaches the lower part of the trunk, it gets darker.*

However, the world we experience and see is defined by light. We see through the two-dimensional pattern of light that falls on the retina of the eye, which is simultaneously conditioned by our understanding and experience. We can describe this pattern of light that we see by making dark marks across a light surface, and forming equivalent patches of light and dark across the paper surface to convey a depiction and understanding of the three-dimensional world compressed to the two-dimensional equivalent of this retinal experience.

How do we draw this world described by light? Line may be used in conjunction with tone, but if so it is usually modulated to relate to the tonal values of the overall drawing. Georges Seurat (1859–91) is a good example of an artist using tone or chiaroscuro to describe light and shadow. He does not distinguish the edges of the elements of the drawing, seeking to find a tonal unity to describe the conditions of light revealing form, defined by shadow. This is done without directional markmaking, and describes the light only in relation to the volume of the objects or subjects in the space of the drawing.

In this copy of a Seurat drawing of a tree, note how the comparative tonal value changes with the description of light against dark and dark against light.

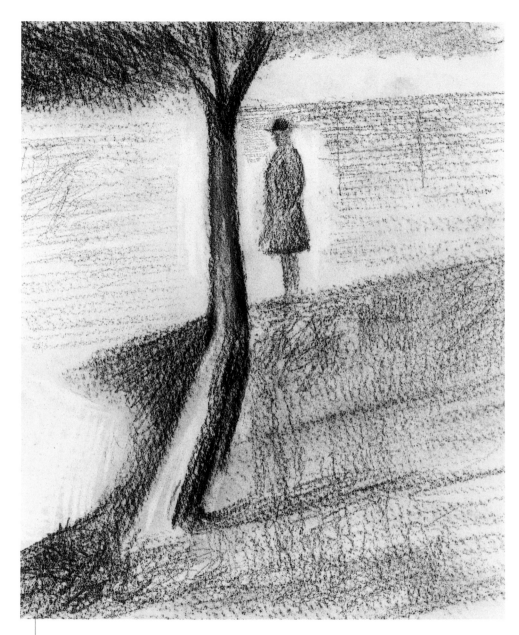

4 | Drawing in this way allows for an interdependence of form to field - one establishes a context for the other. There is no light without a relative darkness and vice versa, where form and field are held in a relative balance.

Mastering tone

Drawings after Seurat

Seurat was a master at describing light through the use of tone. The essential quality of this type of drawing is that it deals with the distinction between a 'form' and a 'field'. Generally speaking, a form is the object and a field is what surrounds it. Art over the last hundred years has been obsessed by this relationship, because essentially this relationship is that of ourselves and our relationship to the world

1 | *Using charcoal or Conté crayon, lightly map in the overall areas of light and dark. Remember that you are leaving light behind and that the surface is organised through areas of tone, to establish the principal areas of light and dark. Begin by using a light to mid–tone, before gradually establishing darker areas of tone. Use very little pressure to apply the initial marks; just allow them to build up. The image will be 'discovered' as though a mist is gradually clearing.*

2 | *Having established a rough idea of the dark areas (and thus the lighter areas) the drawing starts to become more particular, needing a wider range of tone. It is important to increase the range of tonal values by applying more marks over the areas to describe increasingly darker shadow.*

3 | *Small marks accumulate to describe the full tonal range. Seurat's great achievement was to see the mid-tones clearly and fully. Note the changing relationship from light to dark: the back of the head is dark and the field surrounding this form is relatively light. This same domed form gets lighter as we move to the right-hand side of the form, and the corresponding field around it gets darker. Thus the form (in this case, the head) is created by the space around it and is inseparable from it.*

The Seurat drawing, *The Diner (Artist's Father)* (c 1883–4) is made, essentially, by using Conté crayon on Ingres paper. In making a drawing like this, it is imperative not to see the separate components of the overall subject, such as a 'bottle', a 'nose', an 'arm', a 'head' or a 'bowl'. It is important to try not to 'name the parts' of the subject, but to see the whole.

Several parts of the drawing have the same tonal value. For example, the spoon, hand and bowl in this drawing more or less share the same tonal value within the overall picture, but our brain is able to organise them into separate objects, because of the surrounding relationships.

This kind of drawing does not use any line. To begin the drawing, the image is imagined on the paper through a mental mapping process using existing verticals and horizontals wherever possible, and relating those to the picture plane. Look through half-closed eyes to see only the essential areas of light and dark and make marks, which form equivalents to the light and absence of light seen.

The drawing is begun by lightly stating the areas of light and dark with the Conté crayon, the distinction between areas of tone being gradually built up in relation to a full tonal scale. Marks accumulate to describe the objects within the field.

Note how the head is modulated and the features suggested by using a range of tones and marks. The drawing is small and the marks are made with speed and precision. The drawing gradually grows in darkness, which paradoxically makes light. This is clearly demonstrated by the full contrast between the bottle in the foreground and the light hitting the chest of the diner.

Creating a tonal drawing

A sequence of drawings by Kim Williams

In this section, a drawing is photographed while it is being made, revealing the thought processes of an artist who is observing objects from a fixed view-point and adding dark marks to a light surface in order to record the passage of light within a domestic interior. The drawing is made over several days, but the final impact has the immediacy of a single moment in time.

This apparent objectivity, the recording of factual information, masks a more thorough and probing sensitivity about the nature of objective drawing in relation to pictorial representation. This relationship is fundamental to a real understanding of drawing. Clearly the image is not and never can be a full three-dimensional reality. How the artist records the sensation of this reality on paper is the result of a strategy that requires thoughtful contemplation of the nature of the space to be represented.

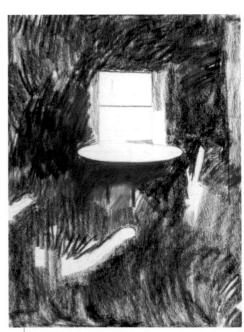

1 | At the outset, the artist establishes the initial composition of the drawing, plotting the space with points and lines, as we saw on pages 76–81.

2 | The tonal relationships are loosely added to this initial framework to establish the main areas of darks.

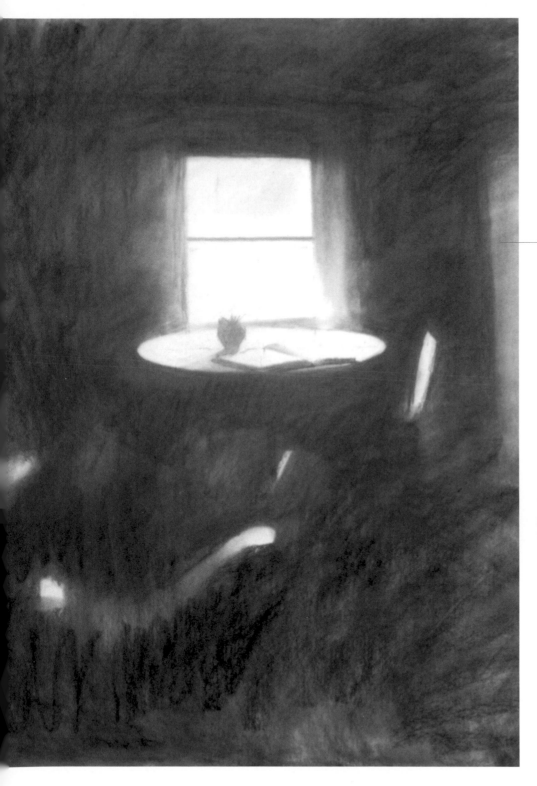

3 | In this drawing, Kim continues to establish the tonal relationships, using a brush to soften and even out the initial charcoal marks. The areas of light are more clearly established and objects start to become indicated on the plane of the table in a lighter tone.

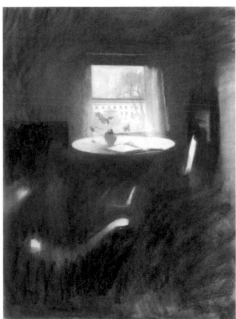

4 | Here the artist concentrates on establishing the darks at the back of the room, the sense of place through the window and the smaller modulations of tonal judgment in the objects on the table surface. As you can see, she works across the whole surface of the drawing, adjusting and making further decisions about the tonal relationships.

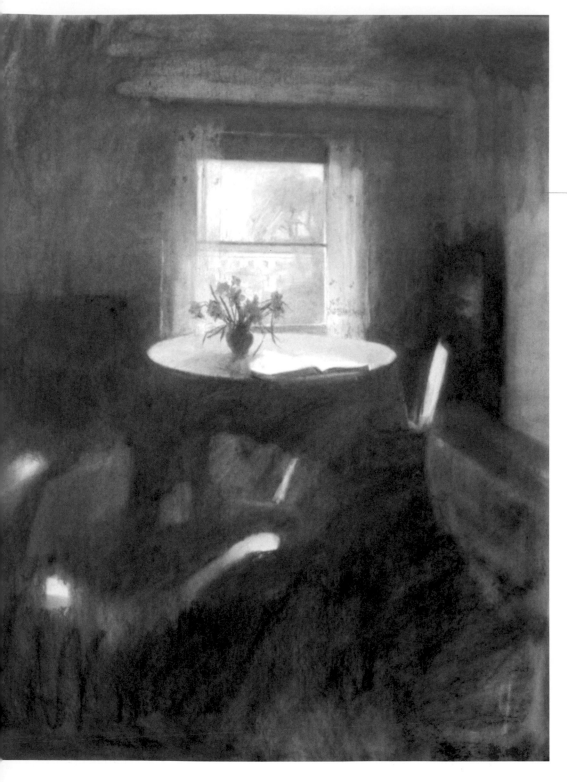

5 | *The flowers in the vase have been introduced and have been made in 'one sitting' as the total focal point at this stage of the drawing, in order to preserve the sense of a singular focus of time as the drawing is resolved. Other decisions have also been made to establish the recession of the interior space.*

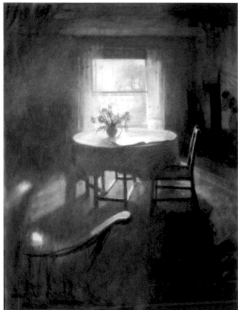

6 | *The way that light floods the room from the window is further explored, and the light falling under the table is described; simultaneously establishing the form and space that the table (and the nearest chair) occupies in the room. The tonal value of the table has been taken up slightly as the overall values are re-assessed and adjusted.*

ADVICE AND TECHNIQUES

- Squinting through half-closed eyes enables you to assess the overall tonal relationships more easily.
- Use a rag or brush to soften and even out the marks made with the charcoal to gain an overall tonal effect.
- This will leave you freer to use the linear marks made by the charcoal for small decisions.

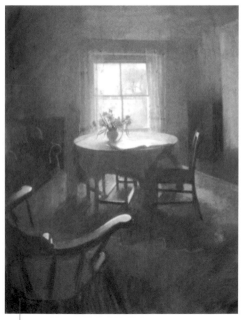

7 | *The tones are being constantly adjusted, and the tonal decisions which define the chairs become realised, as does the space on the left-hand side of the drawing.*

8 | *The artist continues to adjust the tones, mainly using a brush to adjust the pitch of the tone. The pitch of the chair in the foreground is quite high in relation to the rest of the drawing. This is due to the high contrast of the places where light hits the surface of the chair, which is mostly veiled in darkness.*

9 | *The artist continues to adjust the light falling on the chair in the foreground, choosing to push back the strong shape of the chair arms. Kim is also establishing the ground plane, or floor plane of the room, by beginning to state the pattern on the carpet. More information has also been included about the objects surrounding the central subject, at the outskirts of the room.*

ADVICE AND TECHNIQUES

- Keep using the measuring system throughout the drawing to ensure that each element stays in proportion.
- Do not be afraid to make what may appear to be radical decisions to adjust problem areas.
- Do not introduce a white - chalk or pastel. Provided you just use charcoal, you can get back to the white of the paper by using an eraser. Additional pigments will affect the overall temperature of the tonal marks.

Elements of pattern are indicated on the tablecloth | **12**
and the carpet to help progression through space
and across surfaces. Each area has been finely
adjusted and the overall image has great integrity
of tonal and spatial relationships.

10 | *Something quite dramatic has taken place - the chair in the foreground has been removed and replaced with another, more simply shaped chair set further into the room. The artist made some compositional drawings in a sketchbook to decide how to resolve the problem of the original chair, and decided that a chair was still needed as a stepping-stone into the space, but that it needed an upright back to give both height and introduce a different plane into the composition.*

11 | *The chair in the foreground has become more realised and occupies a space within the drawing. The shape of the table-top has been adjusted, also the ground plane and window, and the whole right-hand side of the drawing has been more finely tuned.*

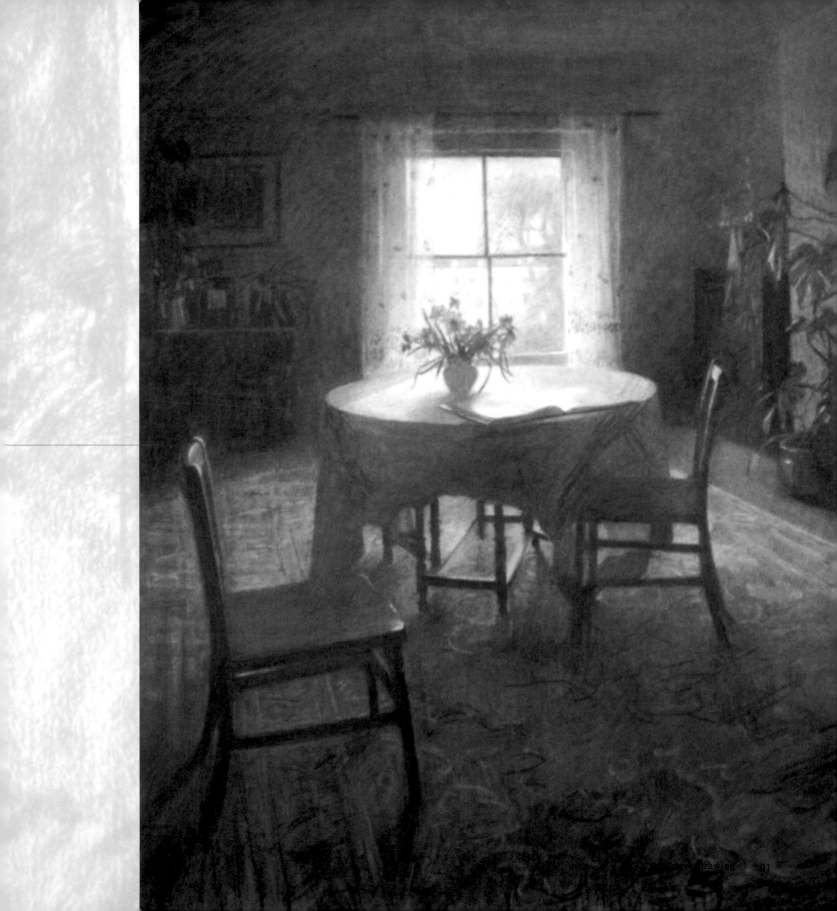

Introducing a figure

A second sequence of drawings by Kim Williams

This sequence of staged photographs introduces a figure to the space. The principles remain exactly the same as in the previous drawing, but the subject is physically more complex and emotive within the space. Note, too, that the model would have been available at various times during the making of the drawing, but not throughout. For practical purposes, this means that, even though the model's presence is essential when she herself is being described, the artist can work on other aspects of the drawing but has to consider the model as well, even when she is not there.

 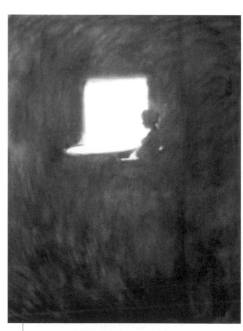

1 | As in the previous drawing, the artist establishes the overall composition of the drawing by plotting and measuring the subject.

2 | The main areas of tone are introduced, in this instance quite dramatically as the interior is darker and the emphasis seems to be on the profile of the figure and the table-top.

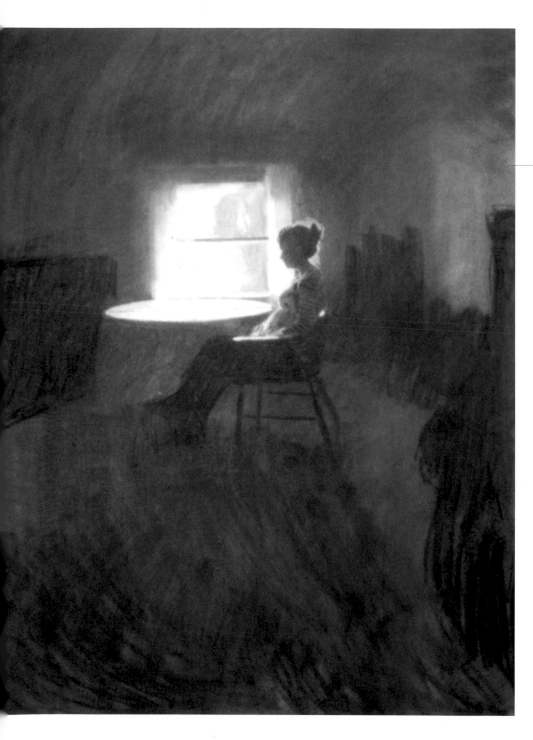

3 | The artist uses a brush to even out the areas of tone, and to remove some of the charcoal dust to create distinctions between overall areas. Now the central subject of the figure and table is more fully located. Areas of darkness encroaching on the central space are also indicated.

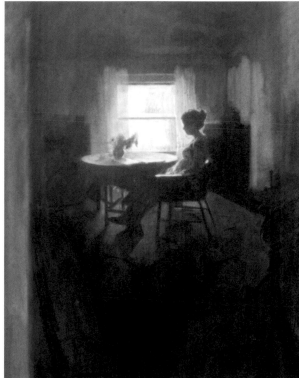

4 | The drawing has developed quite considerably. The floor plane has been established, objects located on the table, the table located in relation to the floor and the figure more fully described. In addition, the viewer has been pushed away from the subject by the introduction of a vertical band of lighter tone on the left-hand side of the drawing, indicating a doorway.

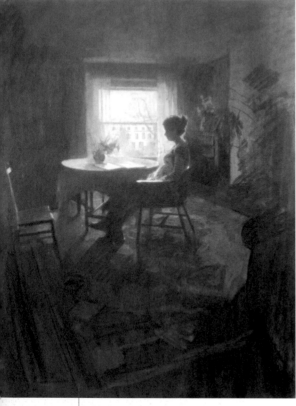

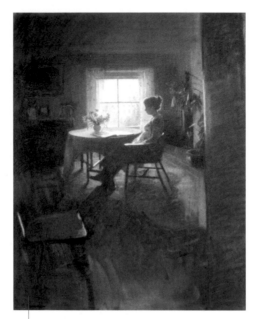

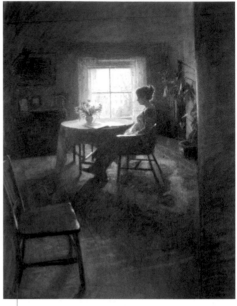

5 | *The artist continues to adjust the space in the foreground, removing the hint of a doorway but introducing a chair fairly close to the table but closer to the viewer (or the artist) than the chair on which the model sits.*

6 | *The chair moves again, closer to the foreground, and starts to act as a barrier to the entrance of the room, and this pushes the main subject further away. The doorway is re-introduced, on the right-hand side of the drawing. It is slightly off-vertical, which reinforces the shape of the back of the figure, and the enclosing box-like shape of the room. The contrast of light and dark has been heightened under the table, throwing the feet of the figure into stronger profile. The flowers have been introduced on the table.*

7 | *The shadow falling from the figure, cast in strong light from the window, is defined falling across the floor plane. The chair becomes more fully realised, as does the area where objects meet and the tonal contrast is clear.*

The overall adjustment of the tonal relationships has continued, and detail of objects, space and furniture included where this augments the understanding of the space. The side plane of the door-frame has been introduced so the viewer can understand where the artist located herself in relation to the focal subject. | 8

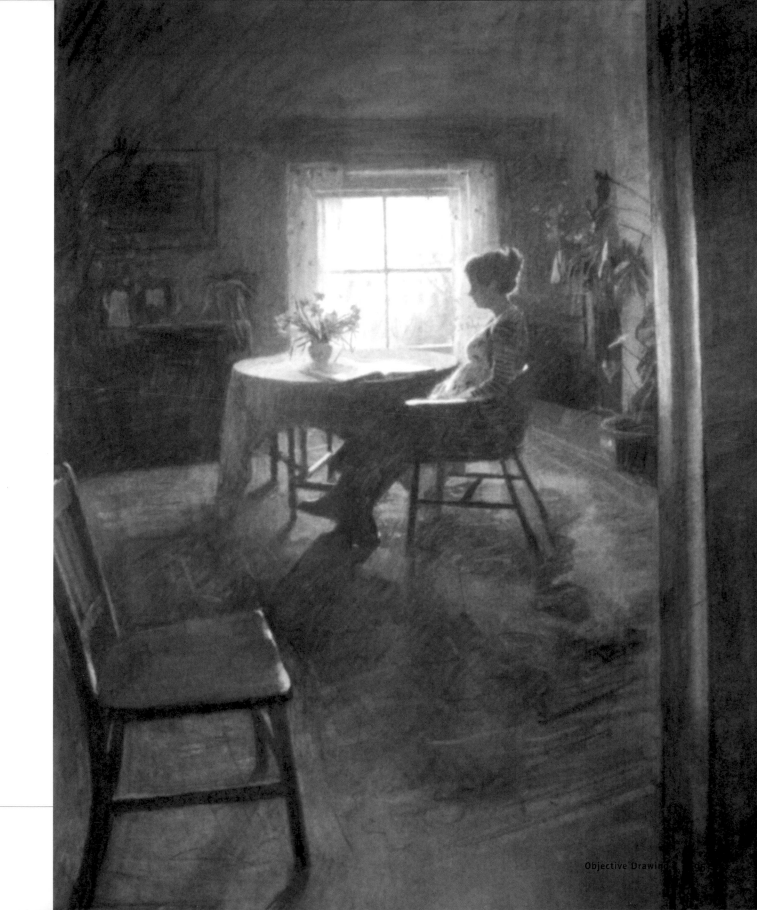

Tone into colour

We have dealt with some aspects of colour, and now it may be useful to make a distinction between drawing in colour and drawing from colour. The world around us is full of wonderful colours, and while we have stressed that a drawing is a construct which refers to the natural world, it is not bound to pure imitation. The following section explores some guiding principles.

There are three terms that most experts agree on: these relate to hue, chroma and value. Hue is the term for a colour. It can be used as a broad umbrella for a range of 'colours' that fall within a family group, for instance a hue of red may encompass brown and pink, but the further away from red it is, the greater the risk of it meeting another hue, for instance orange, which may be part of the yellow family of colour as well as the red family. The second of these definitions, chroma, is a hue in its purest and most intense or saturated state. Value is the lightness and darkness of a hue, which in a black and white image is referred to as tone.

The shift from tone into colour calls for a number of considerations. If you imagine a scale going from black to white, where would you place the colour red? It may be surprising

These three drawings are examples of a 'key' change. The drawing on the left is a half-tone, where a mid-grey is the darkest point and white is the lightest. The middle drawing is again in half-tone, but this time the darkest point is black and the lightest tone a mid-grey. The drawing on the right is known as 'full contrast', which extends the tonal range from the darkest dark – black – to the lightest light – white.

to learn that red, blue, green and violet are all in the bottom third of the tonal range, when at their purest hue. Shades and tints can be made from the original hue or colour, and refer to their lightness and darkness. Any addition to a colour at its most saturated has the inevitable consequence of making it less saturated. A tint is the addition of white to the pure hue, and a shade is the addition of black.

In their correct order on a tonal scale (see diagram), hues at their most intense (purest chroma) are grouped together. The primary colour of yellow is the exception, moving to just over halfway on this scale. This order or scale forms the basis for harmonious colour relationships. If one of these colours jumps out of the order, it creates a discord. This was used to great effect in 20th-century painting, in an attempt to unsettle the viewer's expectations. For example, if purple has an addition of white (tint) it will creep up the value scale until it reaches a point where it will overtake the yellow, and when it does this the visual equivalent of someone scraping their fingers down a blackboard occurs, and the uncomfortable sensation of discordant colour invades the senses.

What can we learn from this? When we draw, we are surrounded by a world of colour. Often drawings are begun on white paper, and as a result the marks we make, by the nature of the materials, add dark marks to a light ground. This in turn pushes the drawing towards a full contrast of tone, but, as we look around the world, our experience rarely has to deal with such full contrasts. As an experiment, place a white piece of paper in the middle of a still-life group, half-close your eyes to take away

the mid-tones and you should notice that the relative value of the white paper is a lot higher up the tonal range than the next lightest light. If you then take away the white paper, you will become aware of the need to locate the tonal range further down the scale. This compression of the scale does bring some problems: it is more satisfying in the way it deals with the lightness and darkness of the group, but quite a lot of decisions have to be made at the bottom end of the tonal range. It is a little like a musician playing in different keys. When playing a piano at the top of the scale, the sound becomes increasingly shrill; similarly, constant repetition at the bottom end of the scale runs the risk of becoming a monotonous

Paul Rosenbloom, *Trace IX*, oil pastel, (1998) 18 x 24 in. *This drawing exemplifies the use of colour when the values are closely related.*

Colour in its purest hue arranged as a value scale. Above is the tonal (black and white) equivalent. It should be noted that yellow is just over half way on the scale and all other colours in their purest form are below that point. Addition of white to any hue, called tinting, would allow a colour (hue) to move up the scale.

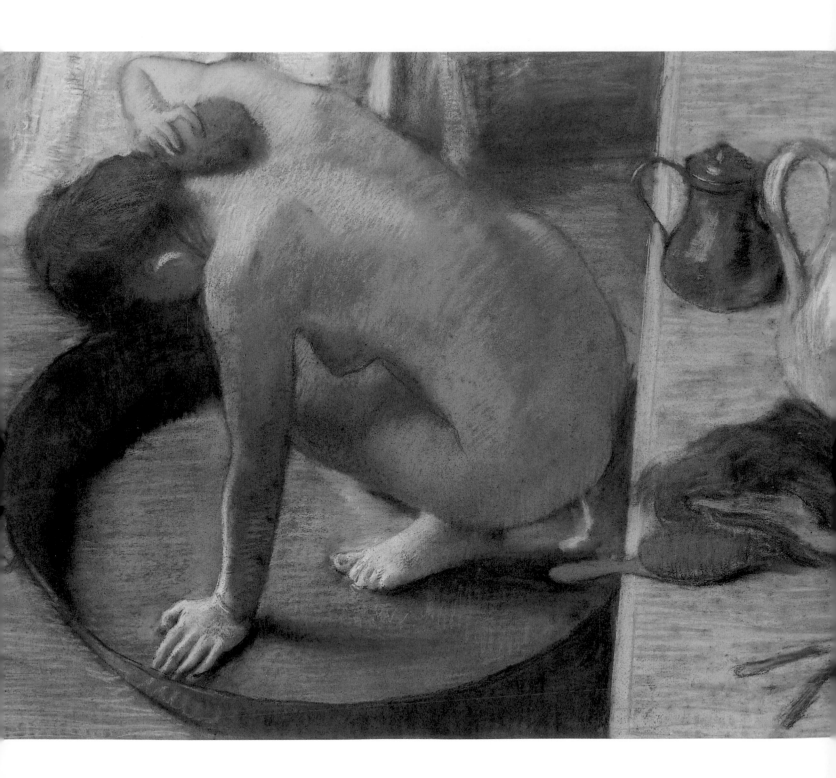

drone. Balance is the mid-tone, between the two ends of the scale, and allows for the addition of lights and darks. If you can work on a mid-tone ground in a flexible medium, it allows you to make judgments, and consequently marks, which are both lighter and darker from the outset.

The images shown on page 96 demonstrate some of these principles. The drawing on the right uses the complete tonal range, and is referred to as full contrast. The other drawings change the key, moving lighter and darker, and as long as the tonal values remain in the same order you can move up and down the scale. Provided you understand and ensure that your tones are consistent, you can play in any key.

Coloured objects may appear to be bright, but this does not always mean they are relatively light. This relative scale can be exploited. Often, artists seeking light will be forced, paradoxically, to structure darkness at the bottom end of the tonal range in order to allow a moment of light to break through with the necessary drama. Rembrandt and Caravaggio are clear exponents of this use of the tonal range. One of the great achievements of Matisse was his ability to use pure colour which, as we have already mentioned, occurs very low down the tonal range – and yet his paintings are full of light. Degas's pastel drawings of women, as in the example shown, exemplify the co-ordination of value and hue. It should be noted just how much colour Degas is able to explore in the darker areas of the drawing (at the lower end of the value scale).

Colour can bring freedom to tonal painting. If Matisse provided a bridge from figuration into this liberated world, abstraction offers apparently limitless horizons. Colour can be enjoyed, sensually revelled in, symbolically pursued, decoratively embellished, discordantly upset, poisonously wrapped or seductively splashed. Colour can signify and code elements of drawing, itemise and contrast, demarcate or add temperatures, be warm or cool. Part of the enjoyment of colour is in knowing, as an artist, what you want to do with it and, as a viewer, in understanding what the artist wanted you to experience. Degas believed that the whole art of colour was in being able to surround a light-red with colours that would make it behave like vermilion.

Pastels offer the purest colour among the drawing media, but are unstable. Even with copious amounts of fixative, the pigment remains suspended on the paper. If an artist wishes to work with pure colour, paint becomes a natural option as a more stable vehicle for colour pigments. (See 'Methods and Materials of Drawing' for advice about the toxicity and stability of pigments.)

Edgar Degas *The Bath* (1886), pastel on card

DRAWING AS
A RECORD

'... I cannot work without a model. I won't

say that I don't turn my back on nature

ruthlessly in order to turn a study into a

picture, arranging the colours, enlarging and

simplifying; but in the matter of form

I am too afraid of departing from the

possible and the true.'

Vincent van Gogh to Emile Bernard, Arles, October 1888.

Drawing as a record

One of the most important elements of drawing is the capacity to detail, collect and collate information, either as studies for other pieces of work, as a collection of thoughts or visual annotations – perhaps of details of a fabric or clothing design, or as a record of an event. The drawings we make as a record are the trace and document of what we see, in a particular context.

In choosing to record a particular event or spectacle, the artist is responding to a personal or individual motive unless he or she was commissioned to make such a record. This might happen in the case of a war artist, for example, or an artist-in-residence or a court reporter. The range of possible situations and subjects is enormous.

The training of artists to deal with this aspect of making drawings includes working from life, both in the Life Room, in the studio, in the landscape, on the street, on location, and in various situations. The artist needs to learn how to make preparations for collecting this information. This may involve finding and selecting the right materials to carry on location, and choosing sketchbooks and notebooks flexible enough to work with in all circumstances. They need to consider what they may wish to find, record or gather information for, and actively seek the subjects they wish to record. They may choose to record things that randomly appear in front of them or which appear to be interesting incidents, or phenomena, in which case they would need to be continually prepared to record such instances.

The artificial context for recording life is the Life Room of an art school, which is so called to distinguish it from the practice of observational drawing from antique casts, which was the other method of teaching the drawing of complex forms in space. This practice also offered the opportunity to learn from other artists and their decision-making. The life model offers the opportunity to explore a unique encounter with another human being. The same condition applies to making portraits, where the relationship between the artist and the sitter is examined by pictorial means. Visualising the features, the overall gestures and the sense of this other person realises the relationship between the artist and the model.

This engraving of the anatomy theatre at Bologna demonstrates the idea of a theatre of space giving a central focus - in this instance the anatomist's table. The design of the elevated viewing forum shown here was later used in the design of purpose-built Life Rooms in academies. The position of the observers gave them a better vantage point, allowing larger numbers of students to see the centrally located model. The Life Room at the Royal Academy Schools in London still has a tiered area for students to work on, although its rake is by no means as steep as the one in this illustration.

OPPOSITE: Anita Taylor, *Seated figure* (2003), pencil in sketchbook, 46 x 30 cm

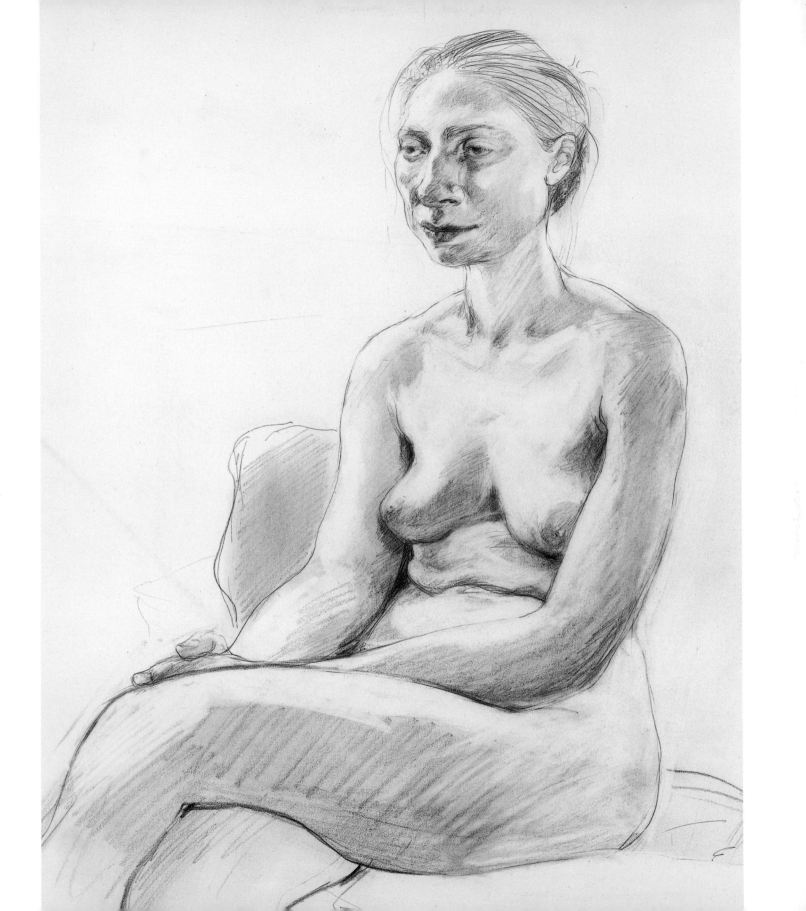

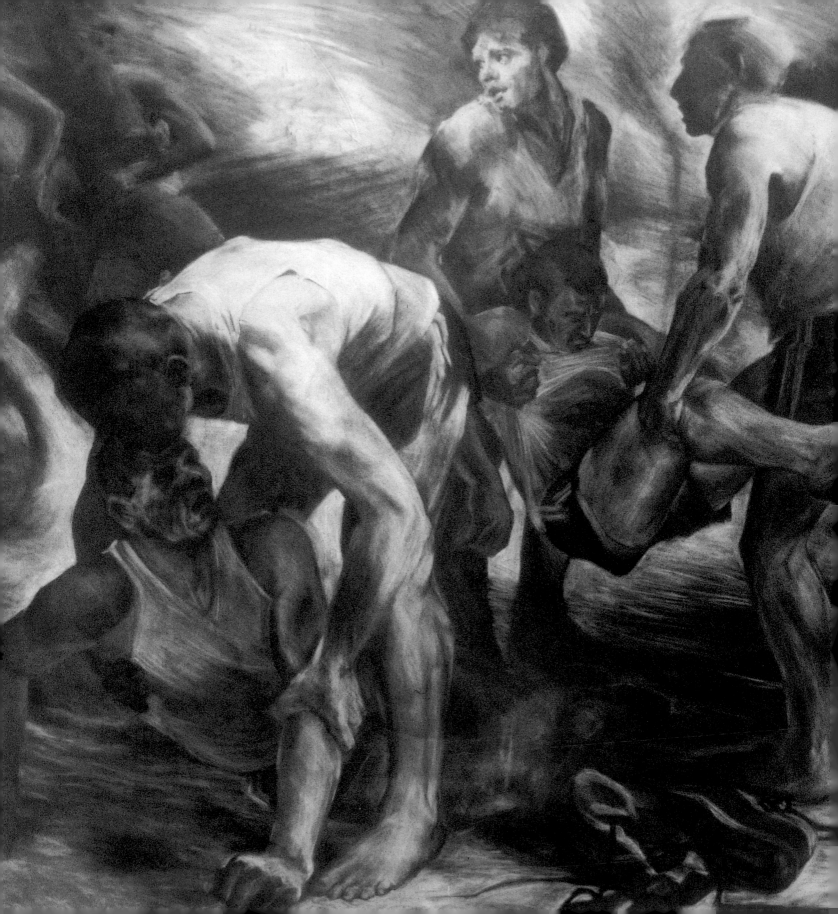

Life Drawing

Drawing from the living model in the Life Room was seen as a primary activity and a basic foundation in the art school curriculum until recent times. It is still upheld as a useful and informative activity in many art schools, but is no longer the required norm, as a more pluralist view has prevailed of what constitute the essential ingredients of the academy curriculum.

The skills of depicting a living subject with objectivity and a sense of life are far more challenging that those of copying from antique casts, the practice developed in academies in the 19th century and which continued until the mid-20th century. The model and the concept of applying mathematical systems of proportion to the human figure made this activity a test of skill and understanding of the fundamental principles of harmony.

Artists have been drawing from live models for many centuries, usually in the artist's studio. Artists learned from other artists in an atelier system, and worked alongside 'masters' to learn their craft as studio assistants.

The atelier system, a kind of apprenticeship scheme, meant that the use and practice of drawing from sitters or models was a much more intimate affair. The exporting of this activity to larger academies, where groups of artists were trained within a school, raised political issues about the subordination of the model in a power

relationship with the artists, and also the issue of voyeurism. The test and challenge of drawing from the living model had been seen to provide a unique and essential element of an art school education. It tested the skills of perception, measurement and all the principles of observational practice. In the 1960s in Europe, this activity was challenged, not only by feminism but also by people questioning the need for tests and standards which were not necessary to the production of every artist's art.

The purpose-built Life Rooms had been designed and constructed on the notion of a theatre, the central subject being the focus of the room and the audience of artists sited around the central stage in a semi-circular or circular fashion, sometimes with a rake or raised floor level to aid their viewing of the spectacle they were to draw. They were modelled on the anatomy theatres, where people went to study as well as observe for entertainment. Few of these Life Rooms built in the 19th century still exist, and are now seen as anachronistic since the styles and needs of the Life Room have changed somewhat within the academy.

The essential quality of the life studio is that there is good light, and the opportunity to use directional light if required to enhance understanding of the surface of the subject for

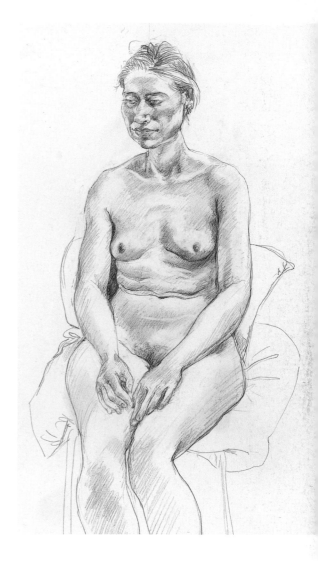

Anita Taylor, *Study of Tam* (2000), pencil in sketchbook, 46 x 30 cm *This is a study from life for a series of paintings, in which a central character is invented. Many drawings were made from the model to inform the invented figures in other works. The drawings are fast and fluid and quickly establish a gesture or expression, without concern for total accuracy.*

Annie Phelps, *The Marathon* (detail) (1989), charcoal on paper, 213 x 213 cm *This drawing is an invented composition around the central theme of a marathon run. The figures are informed by the artist's work in the Life Room, setting up the model in the positions required by the composition and recording this information directly from life.*

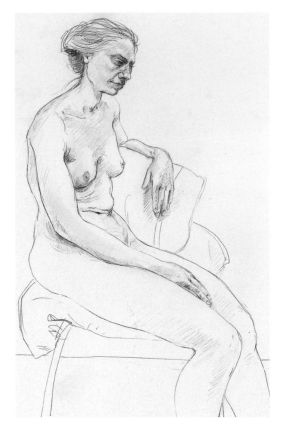

RIGHT: Anita Taylor, *Study of Tam* (2003), pencil/sketchbook, 30 x 25 cm
This study aims to gather information about a certain pose and gesture, to see how the body operates and looks in relation to a particular situation, in this case sitting on a chair.

BOTTOM LEFT: Amanda Nash, *Life Drawing* (1992), pencil on paper. *This drawing was made with great speed as the artist tried to encapsulate the sense of this male model moving through space. She was able quickly and deftly to describe a sequence of movements in partial detail, the summation of which leave a sense of forceful and dynamic movement within the drawing.*

tonal modelling. The room needs to be warm and well ventilated, and to offer good vantage points to see the model properly for the number of artists using the studio. Props need to be available to enable the model to keep a pose, and to support their limbs when pressed against hard edges for prolonged periods of time. Life modelling is a physically demanding occupation, requiring concentration, the ability to hold poses and be adept at working with the demands of the artists. The artists need also to be flexible and to use the model to understand how the body moves, how it works and how to gain the information they require, whether they are drawing from the model for the sake of drawing or trying to glean particular information for another piece of work. The model should rest for at least ten minutes in the hour, and may only be able to hold some poses for very short lengths of time, depending on the level of difficulty.

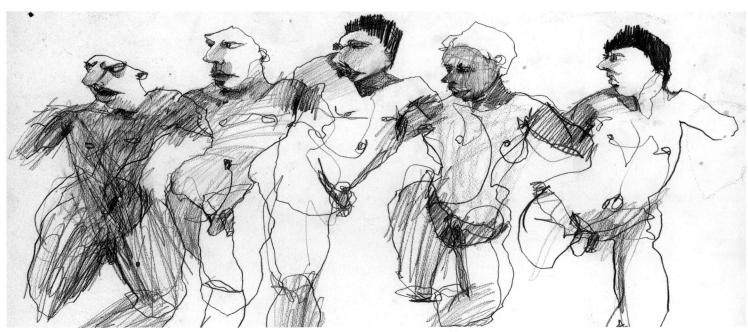

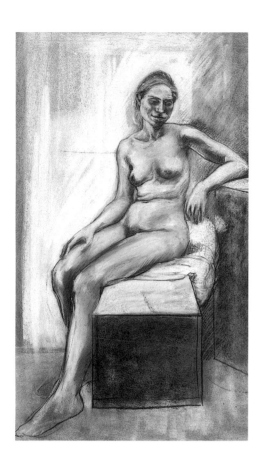

ABOVE: Anita Taylor, *Study of Tam* (2003), pencil/sketchbook, 30 x 25 cm

RIGHT: Annie Phelps, *Life Drawing (Derek)* (1989), charcoal on paper, 100 x 70 cm *This concentrated life drawing depicts the form, volume and overall gesture of the model by describing areas of light and dark. The drawing is worked on to adjust tonal values, while retaining strong contrast to match the physical weight implied in the pose. This drawing was made to explore drawing the figure in a Life Room context, and focuses on recording the pose of the model, gathering information for experience rather than any immediately transferable use.*

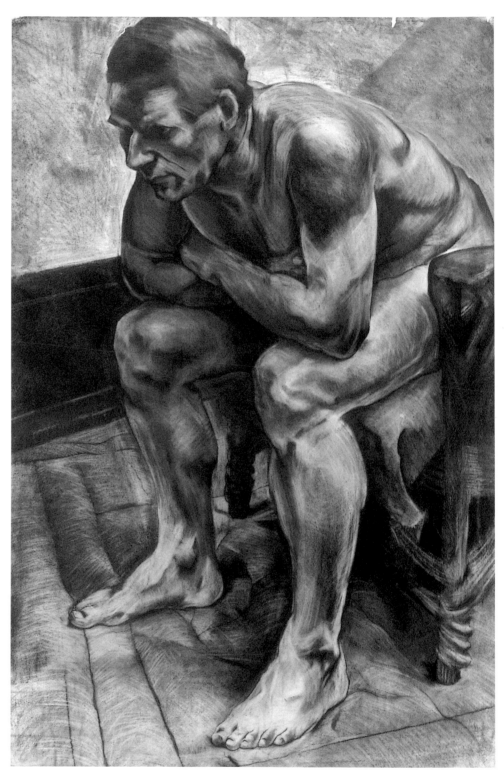

Setting up the model

This involves making a number of decisions about placing the model in relation to the drawing board or easel, the pose of the model, and the props required to enable the model to sustain the required pose. It is worth spending some time working out exactly what is required and asking the model to try different poses, and looking at these from the place in which you will be working. If you have the luxury of setting up the pose and then moving your easel, donkey or other drawing board around the model, then this may also be a consideration.

1 This pose cannot be held for a significant period of time without resting, so the drawing needs to be made at relative speed. Make an overall mapping in the first sitting. Establish your eye level and centre of vision, then locate the key points of the figure - the overall proportion - to ensure that the figure will fit onto the page from the feet to top of the head.

2 You need constantly to re-evaluate the decisions made in the first stage of the drawing, also to establish the 'centre' of the figure and develop the sense of form through the use of line.

3 Here the drawing is further evaluated and the head developed in relation to the overall figure. Patches of tone are introduced to the linear framework to help establish the space between the various elements of the body, for instance the space between the model's right hip and her arm.

Before settling on the pose you want to draw, you will need to decide how long the pose is to be held for and to discuss this with your model. If you are working on a drawing for a period of time, in which the model needs to take a break to prevent numbness and circulation problems associated with staying still for long periods of time, you will need to mark the set-up to enable the model to reposition themselves in the same pose. You can use chalk or tape to mark the parts of the 'set' that the model touches. For instance the feet of the chair need to be marked if the model is seated, and then the location of the model's feet, knees, hips, elbows, wrists, tops of fingers and toes; the points of axis of the structure of the body should be marked where they touch a surface, as should any objects or other articles that you are drawing so you can reinvent the set at any point.

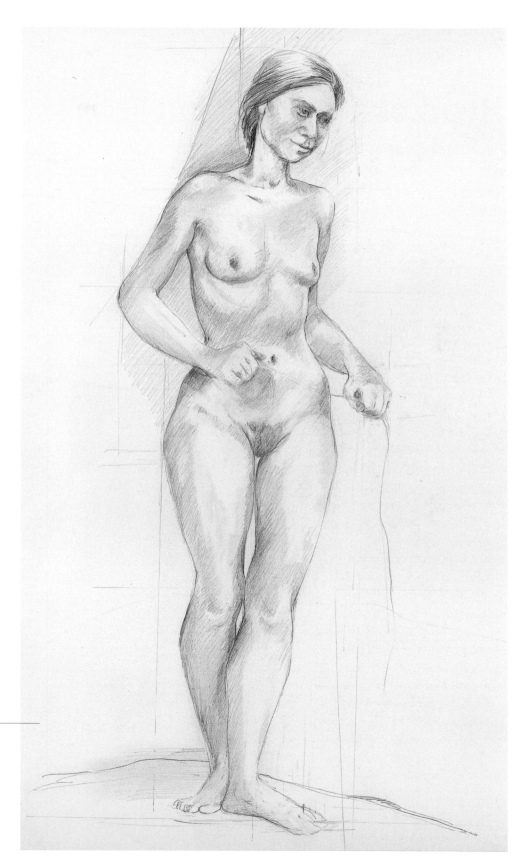

More tone is added to further define the volume of **4** *the model, and begins to describe the modulation of light across the surface of the form, and to distinguish the shifts in direction of the body. Note that the model holds a piece of ribbon between her hands, which enables her to hold her hands at the same distance apart. The ribbon is also marked, as well as the floor, which helps her to hold the pose. The model has a fixed point that she looks at in order to retain the gesture of the head.*

Head of a Young Man

The discipline required in drawing a head is very exacting. We are so familiar with looking at people's faces that even the smallest change in expression is something we immediately notice. A flicker around the mouth or a squinting of the eyes can apparently take the sitter from one mood to another.

The need to achieve a 'likeness' in this situation can become an onerous burden, as this aim can often overwhelm the drawing. It is better to concentrate on making a well-structured drawing than to sacrifice this for the sake of a superficial likeness to the subject. (In the world of caricature, though, this would not necessarily be the case.)

The system of recording used by Raphael (1483–1520) could be thought of as a neutral language. By this we mean the marks made are not intended to be expressive in themselves but rather to convey where relatively less light falls across a form. Acute observation of this phenomenon dictated the careful pace of his drawing (see copy, right). It could be added that any dramatic change of pace, such as a more gestural mark, would be unhelpful in this context as it would be read as an area of relative darkness.

In both of the drawings shown here, the heads are seen against a lighter background. This indicates that they are to be seen as studies, which closely examine the form and not the relationship of the form to the field. Such studies serve a useful purpose in getting to know the subject, but if they were developed into a painting they would probably need qualification through context to show how they relate to space or to other forms. Rarely would heads like these be seen in isolation.

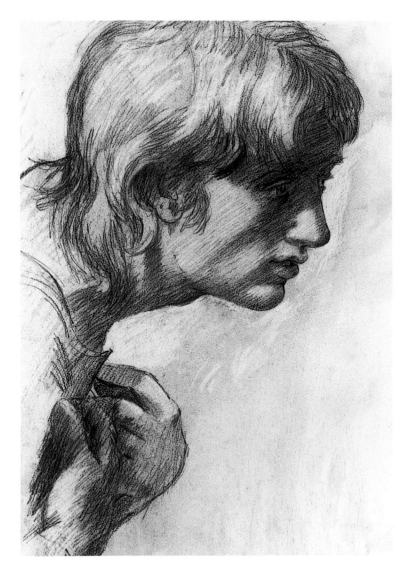

ADVICE

- When drawing a portrait head, try to draw the head at life size.
- The face itself, without the skull, is no larger or smaller than the size of your hand.
- The distance you would stand to view a portrait head is probably the distance at which you would have a conversation. Thus if you reach out at arm's length, their face would fit into your hand.

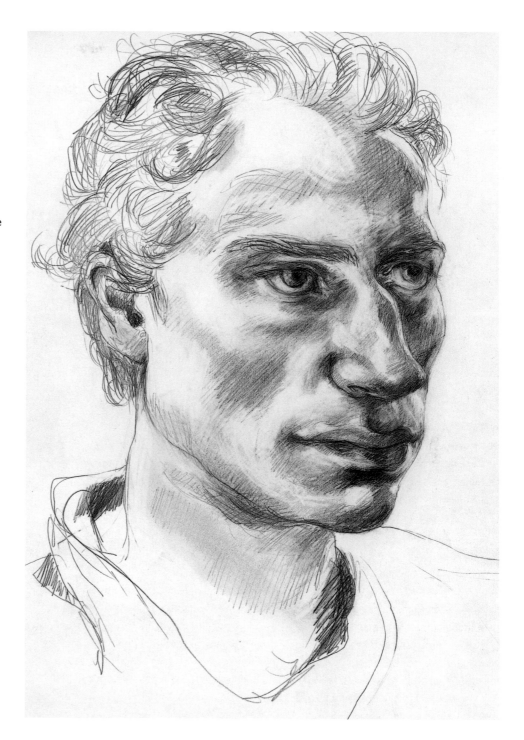

OPPOSITE: Paul Thomas, *Drawing after Head of a Young Man by Raphael,* Ashmolean Museum, Oxford.

RIGHT: Anita Taylor, *Marc,* pencil on paper, 30 x 25 cm

Landscape

The same principles apply to drawing in the landscape as to any other form of drawing. The artist needs to ask questions about his or her purpose to determine the scale, format, language, medium and descriptive properties to be employed to describe the landscape.

First of all, establish how you are going to work. The weather can be extremely unpredictable and variety may well be the making of your drawing, but it can also be its downfall. Working in sketchbooks is quick, easy and convenient. Here one of the problems would be the use of wet media. Cheap paper will buckle and pages stick together. Taking a drawing board and paper allows for a wider range of responses, but once again decisions have to be made about how much information can be recorded at one sitting. Therefore, careful planning and preparation needs to take place to accommodate all these eventualities.

The drawing on this page looks at the landscape it depicts over a period of a day; the changing light and climatic conditions are adjusted and reworked as the drawing proceeds. Substantially, the main elements are fixed but the emotive mark-making allows for a sensual response to be attached. In a drawing like this you are invited to feel your way across the terrain with your eyes as you empathise with the artist's experience of being there.

In contrast, the copy of a Constable landscape, opposite, captures an elusive moment just after a thunderstorm. The wateriness of the watercolour medium contributes to the feeling that you have been caught in a downpour. The lightest areas in this small drawing remain constant throughout the making. The areas of relative darkness gradually assemble, making a readable landscape. This drawing has a faint pencil line, evidence that Constable noted down the architecture of the church and a rough outline of the trees. These are the features that would remain constant, and allowed him to attack the climatic change with such vigour and panache.

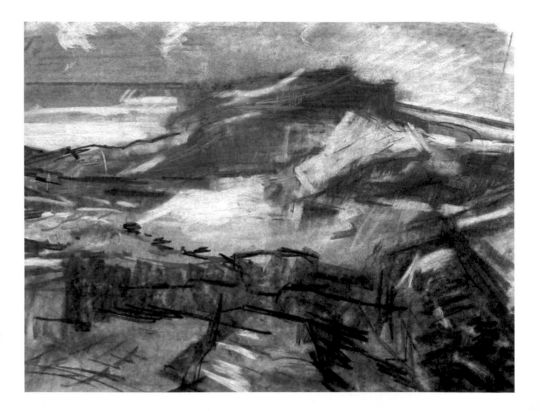

Chris Thomas, *Helicopter Rock* (2000), charcoal on paper, 58 x 84 cm.

Paul Thomas, *Drawing after Constable,* watercolour on paper.

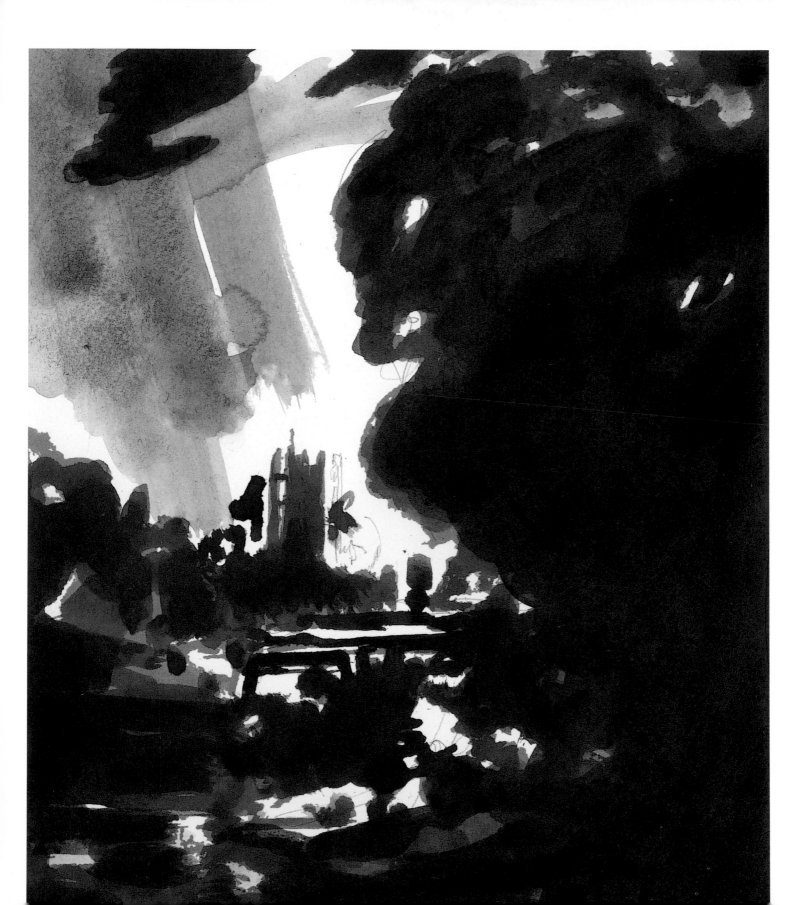

DRAWING FROM
THE IMAGINATION

'If you look upon an old wall covered with dirt, or

the odd appearance of some streaked stones, you

may discover several things like landscape,

seascapes, battles, clouds, uncommon attitudes,

humorous faces, draperies, etc. Out of this

confused mass of objects, the mind will be

furnished with an abundance of designs and

subjects perfectly new.'

Leonardo da Vinci, *Treatise on Painting*,
prepared c 1540–50, first published 1651.

Subjective drawing

When we draw from our imagination, we gather together the strands of our visual experiences, link them with associated memories that can incorporate all of our senses and try to reform the world in one coherent image. Having identified a subject, we try and find the right form in which to express our thoughts and feelings in relation to the subject.

It could be said that a successful synthesis of these thoughts and feelings is in fact the content of the drawing. Children draw bringing all their senses into play. If only we could learn to do the same. One of Picasso's more obscure deliverances was that 'They should put out the eyes of painters as they do chaffinches, so they might sing more sweetly.' What he meant is that our 'seeing' has itself inhibited the enormous possible vocabulary at our disposal. If only we were free from the restraints of naturalism. If we could make a mark that in itself expressed anger or joy, then an abstract set of marks should be able to convey emotion, like the notes in music. Subjective drawing merely tries to utilise all aspects of drawing practice in a unique synthesis, forming a composite view.

If we just draw, what do we find and what do we see? The doodles of our disengaged minds are often extremely revealing. In the way that our dreams tell us something about ourselves, so our drawings can do the same, if only we would let them. The doodle offers unmediated dream-time. This drawing course offers the opportunity to contemplate marks

and images made intuitively. For the artist, it is a balance between what you know and what you don't know. As with a horse and carriage, the horses lead, but they don't know where they are going. Sometimes we go with them, and sometime we need to redirect them.

Is there such a thing as a subjective drawing? The idea that an image can be completely subjective is not possible, or even very interesting. It is the way in which our experience of the world around us, and its fantastic variety of shapes and forms, can be transformed into compelling images capable of ever more inventive associations. It is through these carefully mediated associations that poetry comes into being. The world around us waits for us to recognise its potential in poetic observation.

Random jotting around a telephone number. It is a mixture of decoration (embellishment around a single point) and objects or patterns randomly inserted. The important point here is that there is very little conscious mediation.

OPPOSITE: Paul Thomas, *Athena Rescues Paris from Menelaus*, pencil on paper, 56 x 76 cm. *Taken from Homer's* Iliad, *Menelaus the Greek warrior attracts Paris, the Trojan prince, who had abducted his wife Helen and thus precipitated the Trojan War. Here, Paris (on the right) is literally being taken out of the pictorial space by the goddess Athena, who shrouds him in a swirling mist. The substitution of herself for Paris is an essential part of the understanding of the drawing, the idea that she exists and at the same time is not part of the same reality is what the drawing tries to tackle. The shield in the centre is used as a fixed formal device, which spins the two protagonists around. Menelaus's eyes and sword point as diagonals to where Paris's head has been displaced by Athena's visage. The drawing is about stability and displacement.*

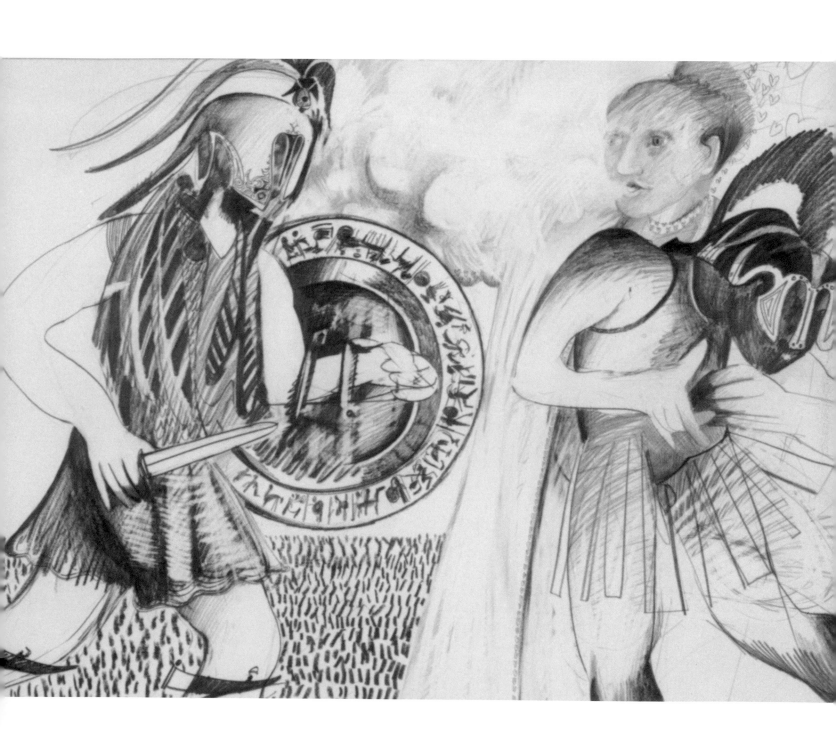

A drawing course

Marks into shapes

This innovative drawing course was devised by Paul Thomas in 1980. It looks at the relationships of individual exploratory mark-making, the organization of marks into shapes and associative interpretations, and then the augmentation of information through this system of drawing to use information found in the 'objective world'. The course shares a fundamental principle with that of the Rorschach inkblot test, in that it invites the maker of the mark to interpret the mark they have made after the event.

The quotation from Leonardo da Vinci, at the beginning of this section, was noted by the artist Alexander Cozens in his publication, A New Method of assisting the Invention in Drawing Original Compositions of Landscape *(c 1785). He proposed a technique of blotting ink which speeds the inventive recognition of shapes and forms. A hundred years later, the Swiss scientist Hermann Rorschach made a clinical study of how people 'read' or 'project' their own subjective interpretations on an ink blot.*

However, it offers new and subtler opportunities and also the flexibility to change an infinite number of relationships. The final result is not presented as a Freudian analysis, but rather speculates on an evolving set of priorities, which can be accepted, negated or transformed. It is for this reason only that charcoal is used for the drawing you are to make.

This structured drawing is designed to enable you to explore the possibilities of free association. It is not intended for you to make as many associations as possible, but to focus on a) the formal propositions offered by the drawing, and b) the results of your decision making. It is interesting to note that a formal decision can have dramatic consequences in terms of meaning. If I remove a part of the drawing for formal reasons, I must recognise that it is also my decision to take away a part of the image, thus causing a number of changes in the potential relationships that other parts of the drawing might have had. For instance, if I take out a sharp spiky shape, it may have been the very shape that defined something else as being relatively softer; as a consequence of this, it may now be that the softer shape is relatively hard against an even softer part of the drawing. Nothing exists in a vacuum, and it is the beautiful balance and fluidity of relationships that creates excitement

and tension in the formation of a subjective drawing. The end product is a bit like a discarded snakeskin. It may be very beautiful, but through the process of change and growth it is no longer needed. The process and the transformation is the motivation for the drawing.

The paper you work on should ideally be more than 1.5 m diameter in at least one direction. This is to enable you to make marks which extend those made naturally within the everyday gesture of your hand movements on a smaller scale. The paper will need to be of a reasonably substantial weight and with a relatively neutral surface, although it will need a surface with enough tooth to hold the charcoal. An ideal paper would be Fabriano 4, or Arches drawing paper, both of which are available on a 10 m roll, or in large format sheets.

The only medium to be used is charcoal, scenic or willow, which is a flexible medium, and can be used to apply marks which can be erased by rags or erasers to get back to the 'white' of the paper surface. This is an important principle, as your drawing will require you to explore and play with the materials (charcoal and paper) as much as possible, and to take many decisions during the making process. You will need a large box of charcoal for this drawing. Begin by fixing the paper to a flat surface (wall or board).

1 | Start by making a series of marks that cover the whole surface of your paper. The marks should contain as much variety as possible (if you find it hard to invent different marks, have a look at some Van Gogh drawings). At this stage the marks should neither be carefully ordered nor selected. The more random and diverse the selection the better. Enjoy and explore what charcoal can do.

2 | Make sure you get out into the corners of your drawing and begin to add some directional lines. These lines can respond to vagaries that may be prompted in the preceding stage. Again, you should not have any real idea of what is happening but merely that you are trying to keep the image varied and fluid.

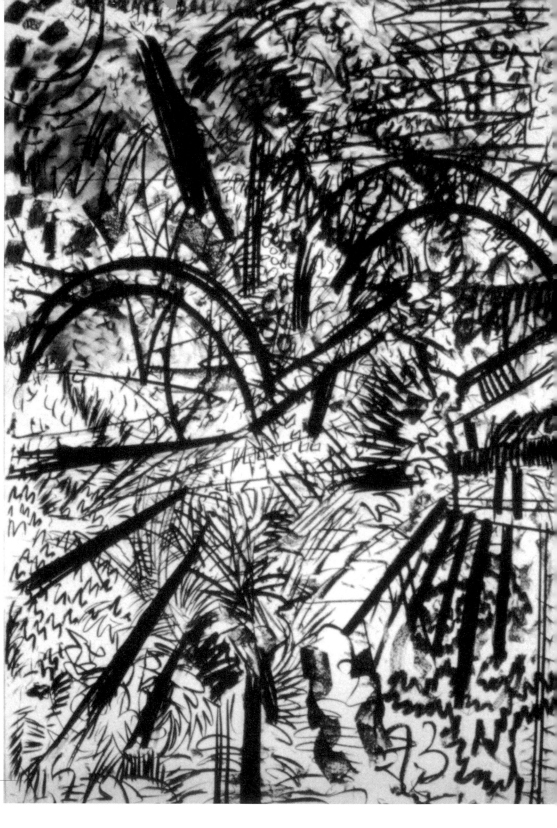

3 | As the drawing accumulates more marks, it begins
to get darker. Areas begin to consolidate with the
addition of more lines. There is still no discernible
subject matter but the drawing begins to take on a
dynamic presence. Try to avoid symmetry. Here the
drawing tilts to the right, but the centre remains
an easy fixed point, a form in which shapes appear
to circulate.

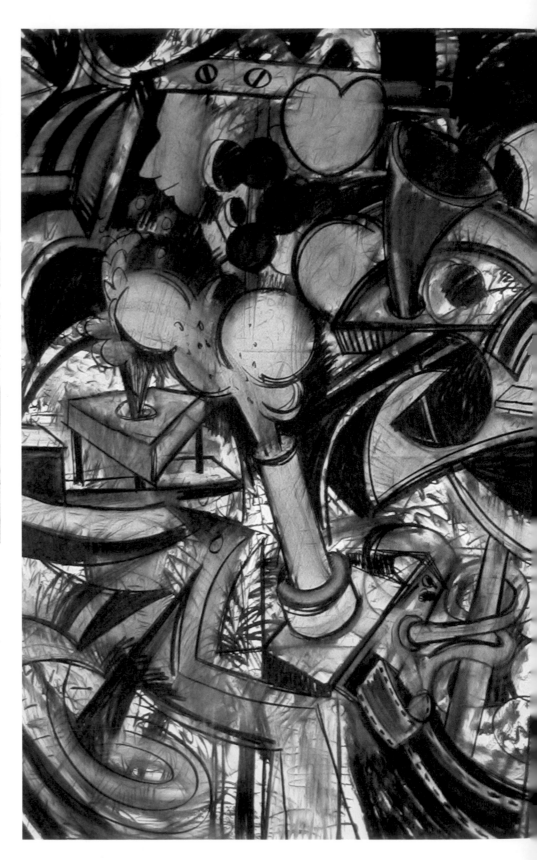

4 *The surface gets busier and denser, and within areas formal games can take place. Here you can have some fun inserting forms into shapes. With its richly varied surface, the potential of this drawing is enormous. If you can get your drawing to this stage, you have won half of the battle. From now on you will notice that decisions are largely based on the closing down of alternatives.*

ADVICE AND TECHNIQUES

- Look at the drawing in a mirror periodically to help give you an objective view of the overall organization of the drawing
- The subject matter of the drawing will gradually emerge as the drawing proceeds. This may (and will) necessitate changes in the drawings, and it is important not to be worried about making changes. The subject matter may develop figuratively (recognisably referring to the objective world) or non-figuratively (abstract).

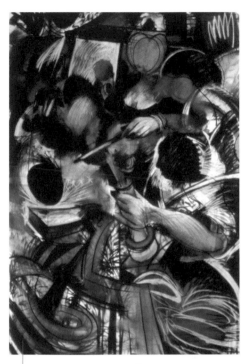

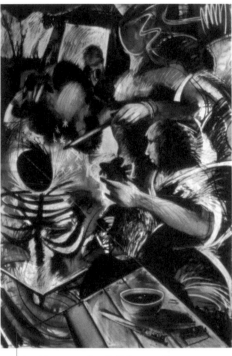

5 *As two shapes reach into the middle, the artist has allowed them to become hands, and in doing so they have been allotted an object. For the first time, the drawing begins to lay claim to a subject. Each subject is of course individual to each person making a drawing in this way.*

6 *In the preceding drawing there was a momentary opportunity to see the centre of the drawing as a large bird's head, which would have led the artist perhaps towards consolidating a much larger totemic form. The decision to make the right-hand black circle into a profile removed its potential as an eye. Instead, tracking back from the hands, arms appear which seek to locate bodies, and although indications of such appear, it is still some way before clear recognition takes place.*

7 *A table appears but is little more than an excuse for the major formal introduction of a diagonal. This diagonal, which originates in the bottom right-hand corner, projects a line which finishes two-thirds of the way up on the left-hand side of the drawing. The other side of the table contains a diagonal, the origin of which is in the bottom left-hand side of the drawing and, were it to complete itself, would end two-thirds of the way down on the right. These decisions were prompted by what appears to be a magician's wand, and the measurements are in fact not quite two-thirds, but in fact 55:34 inches, which is 1.618 of the whole. This proportion is a golden section. The artist is having a playful look at subject and form being linked, and the accompanying objects appear to share some interest in the alchemical goings-on.*

ADVICE AND TECHNIQUES

- If in doubt keep working the drawing, and inevitably more will emerge.
- Continue to be flexible and inquisitive throughout the making of marks, shape, forms, volume, and objects, subject and content.
- Explore the qualities of an object through its surface – is it shiny, matt, gaseous, brittle, dry, heavy, liquid, hot, cold – how do you make marks that suggest or are equivalent to these qualities?

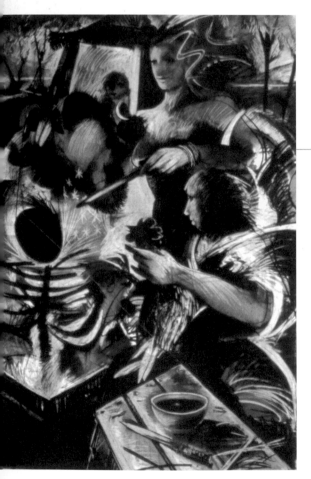

8 By now the subject of the drawing has become clearer, and the introduction of a rooster held in the left hand of the figure in the foreground makes an interesting formal link through the sharpness of its claw. There is still indecision and lack of clarity in the relationship between this figure's arm and body.

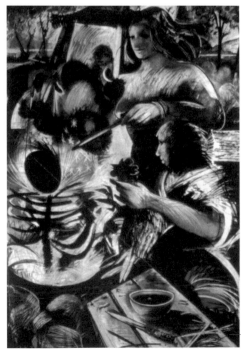

9 The landscape that has been forming in the background now has a river that cuts as a horizontal and divides the drawing. On the left-hand side, a semi-circle controls an area of uncertainty in which there appear to be some shenanigans taking place. The main figure is going through a crisis as the artist seeks to re-establish some proportion. It should be noted that some areas are facing minimal change, whilst others will need clear direction in order to integrate them into the overall pictorial structure.

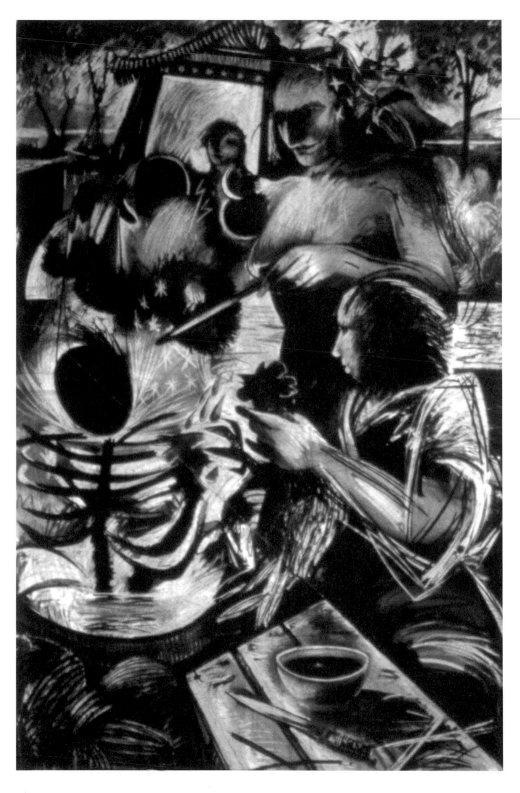

10 | *A major re-working of the arm belonging to the figure in the foreground takes place, which will ha[ve] repercussions leading to a complete redefinition of this figure in space. The main figure still needs an appropriate width across the torso to be established. The stars in her hair and crows in the sky form a poetic link with the landscape behind.*

11 | *Furthering this link, the figure in the background, which had appeared within the shelter of a pagoda-like building, wears a silly hat as the artist tries to lighten the mood of the drawing. Similarly, the arm becomes more resolved and quietens the right-hand section with less frenzied mark-making.*

ADVICE AND TECHNIQUES

- Retain flexibility, experimentation and question the drawing throughout the process of making.
- Don't use chalk or any other additional materials, including water.
- Hitting the drawing with a rag will dislodge charcoal without smudging
- Plastic erasers are more suitable to this kind of drawing
- Leave a margin around the edge of the paper, use it to frame your image.

By the time the drawing reaches this stage, it has served its purpose. The drawing has identified its subject, which was the nature of drawing in this way. The difficulties of formally orchestrating an image have been explored through the parallel of alchemy. In trying to elevate marks into meaningful relationships, one attempts to transcend the origins of the simple materials. **14**

12 | *The introduction of stripy material has formal links with the skeletal rib-cage on the opposite side. The self-conscious seriousness of the drawing is further removed by the more Disney-like princess figure. Clear stylisation of the hair and bodice, with her sharply defined features, makes her altogether more stereotypically Disney-like.*

13 | *The drawing is nearly complete and it only remains for some tidying up to be done, as the removal of some areas of tone creates a lighter feeling.*

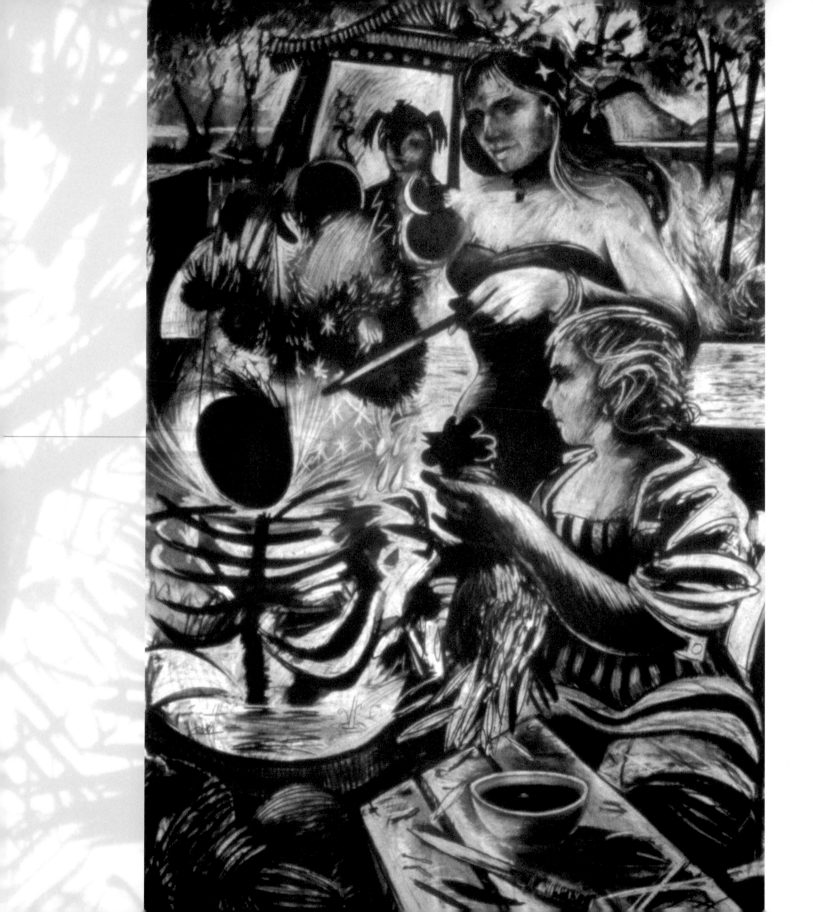

ANITA TAYLOR

A GALLERY OF DRAWINGS

Anita Taylor makes large-scale charcoal drawings which explore the relationships of the female subject as artist, model and portrait, through the defining acts of scrutiny, gaze and feeling. The relationships explored involve what is seen, what is felt and what we expect; there is an inherent paradox as the mind reveals the body it inhabits.

The images are substantially larger than life, and challenge and expose the scale of the private dialogue about the bodies we inhabit and that of the scale of exposure in our minds. The use of charcoal is flexible and can be adapted and adjusted to describe both fine detail across the surface of the skin, and bold gestural marks in relation to the physicality of the body.

OPPOSITE: *All and Nothing* (1999), charcoal on paper, 170 x 114 cm

All and Nothing *depicts a naked female figure, who is seen and yet not seen as the gesture of her arms conceals and protects her from view. It is an image of apparently everything and nothing.*

RIGHT: *Containing Things* (2000), charcoal on paper, 175 x 112 cm

In this image of contentment, the eyes are closed containing no communication, and the gesture of the figure separates her from the viewer. The idea behind the drawing is that of the fragility of our outer presentation to the world and the need to hold on to inner feeling, sensation and the threat of disintegration or disjuncture as we become exposed.

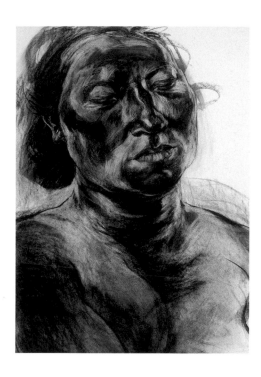

ABOVE (full picture) AND OPPOSITE (detail):
Somnambulant (2001), charcoal on paper,
150 x 113 cm
Somnambulant *aims to describe and depict a
narcoleptic slippage of consciousness; a veneer of
appearance, which is both aware and oblivious.*

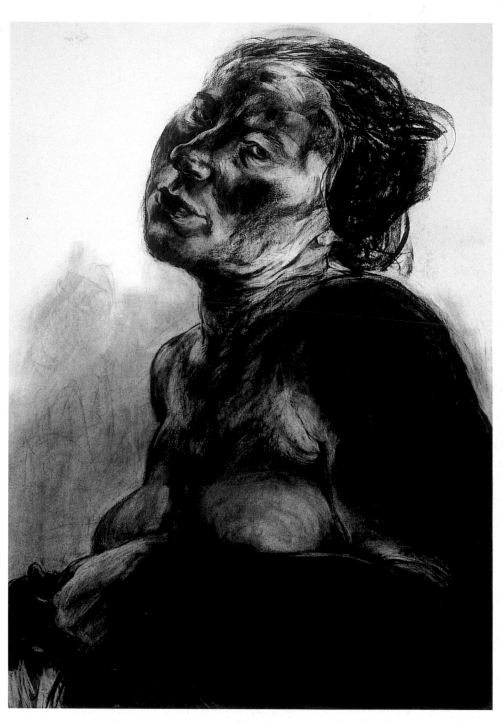

RIGHT: *Disclosure* (2000), charcoal on paper,
160 x 123 cm
*This is a drawing about a suspended moment during
which the subject contemplates the moment before she
will disclose her body - to the mirror in which she will
see herself. This moment is the drawing itself.*

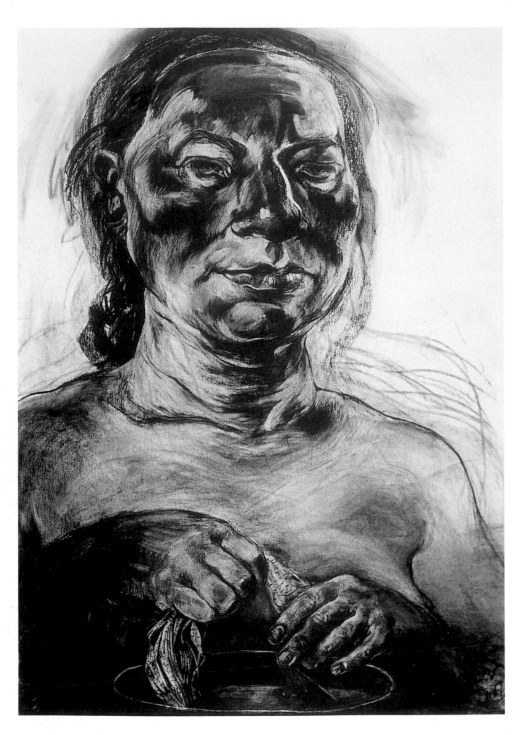

LEFT: *Cleanse* (2002), charcoal on paper, 182 x 136 cm

In this drawing, the wringing of the cloth and its potential for cleansing relates to the idea of erasure, which reveals the form within the drawing.

OPPOSITE: *Resigned* (2002), charcoal on paper, 182 x 136 cm

This drawing examines the reflection of the subject, the expression of the figure is tired and describes a sense of acceptance of something. The gesture with the arms is self-protective and restrained.

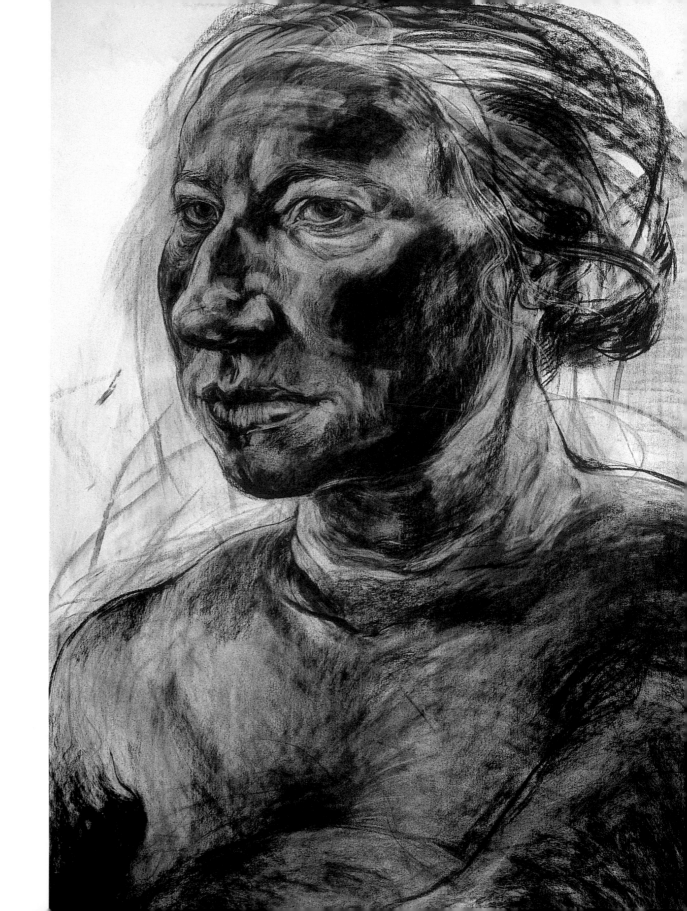

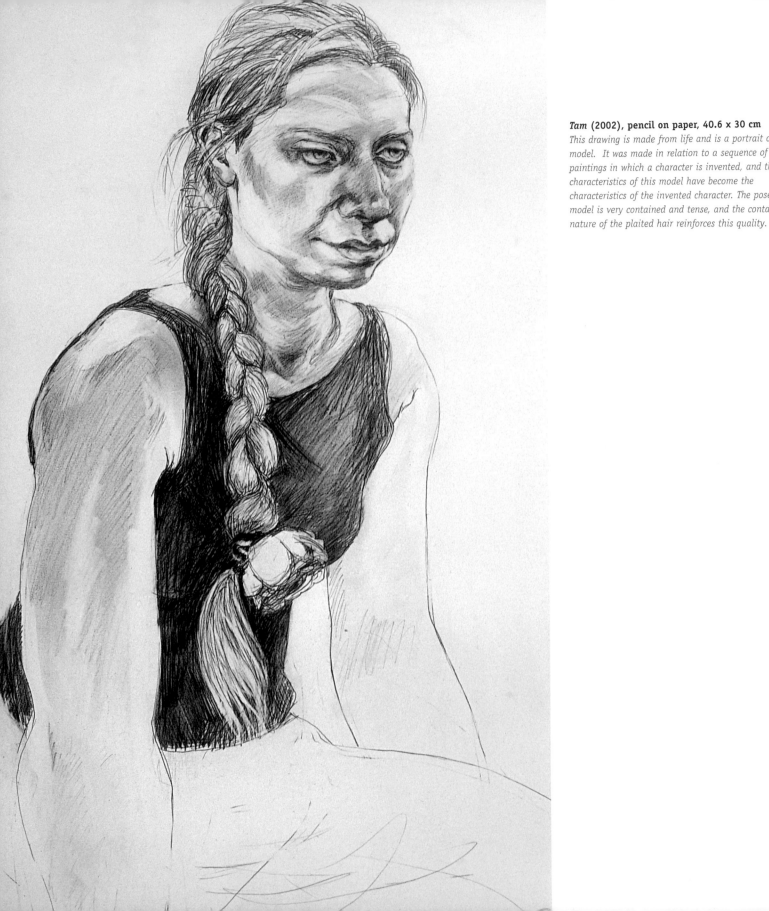

Tam (2002), pencil on paper, 40.6 x 30 cm

This drawing is made from life and is a portrait of the model. It was made in relation to a sequence of paintings in which a character is invented, and the characteristics of this model have become the characteristics of the invented character. The pose of the model is very contained and tense, and the contained nature of the plaited hair reinforces this quality.

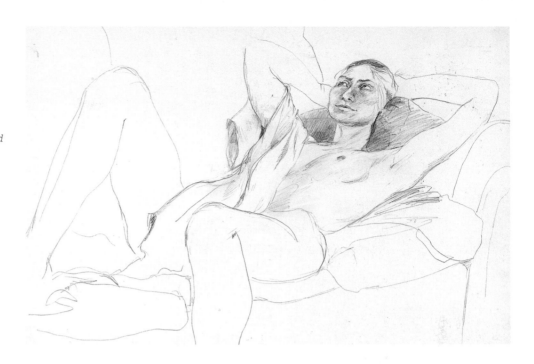

RIGHT: *Reclining Model I* (2002), pencil on paper, 30 x 25 cm

The first of these drawings of the reclining model establishes the placement on the page of the model and the viewpoint of the artist.

BELOW: *Reclining Model II* (2002), pencil on paper, 30 x 25 cm

The second version of the drawing, made in quick succession to the first, has adjusted the pose of the model to appear more casual and relaxed in the position. This has the effect of enhancing the sense of reverie, and the rhythms of the fabric and furniture further enhance this quality.

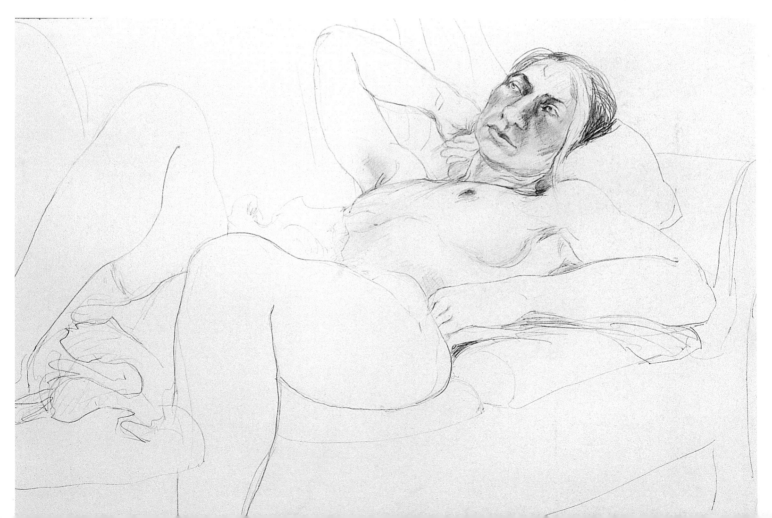

PAUL THOMAS
A GALLERY OF DRAWINGS

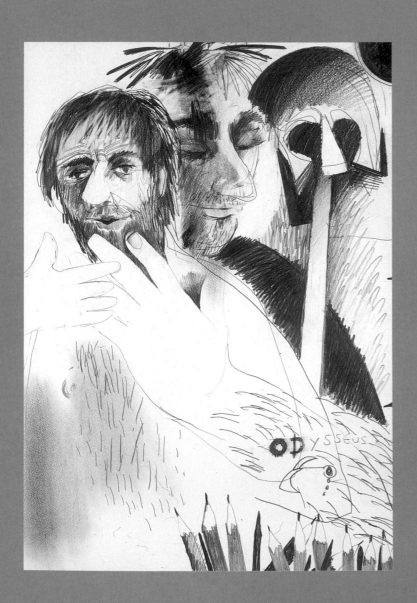

Over the past ten years, Paul Thomas's work has been concerned with the question of understanding a shared European identity, and how to produce a contemporary reinterpretation of historical European narratives. The focus for this has been an exploration of early mythologies and narratives derived from Greece and Rome. These centre on Homer's *Iliad* and *Odyssey*, and use images developed from these stories to explore our changing values in relation to heroic struggles and idealistic aims in the present.

These two narratives encapsulate a European history rich in symbolic associations. They have provided the model for subsequent narratives, and allow for a continuing and dynamic dialogue with the classical world.

The drawings are influenced by many diverse artists, including the Greek vase painters, Flaxman, Picasso and Twombly. They seek to synthesize a range of drawing language, contextual information and narrative and to forge a new, visual interpretation of the underlying themes of the various texts, from Aeschylus to Ovid. The resultant drawings are sequential and The Trojan War and The Odyssey series contain 160 images, which refer to specific key quotations, and which are to be published with a third volume of drawings to Virgil's *Aeneid*.

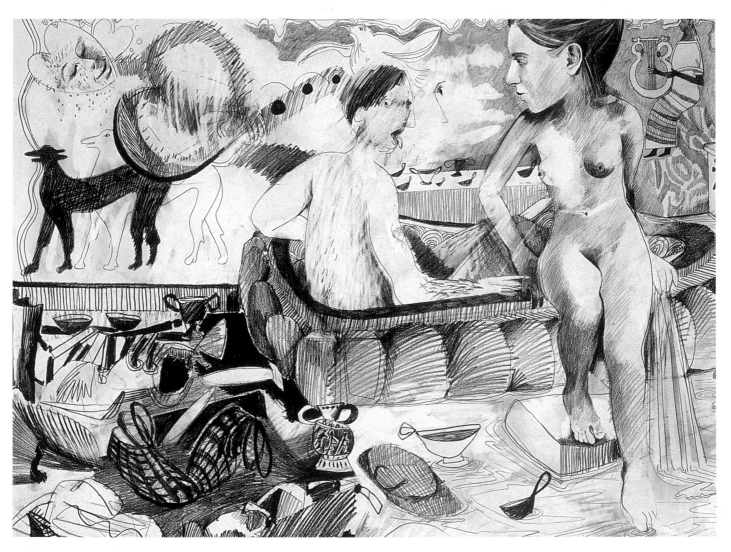

OPPOSITE: *I Am Odysseus* (2002), pencil on paper, 56 x 76 cm

This drawing sets a framework for Odysseus, revealing his identity at the court. Set in the middle of the series, it contains the revelation that the artist has constructed an imagined world and that his hand is also the hand of Odysseus.

ABOVE: *Telemachus and Polycaste*, pencil on paper, 56 x 76 cm

The subject of this drawing is the gauche Telemachus, son of Odysseus, on his first real adventure away from home. The beautiful Polycaste, daughter of King Nestor, has bathed with the young man and his excitement is clearly evident. Uncertain of how to proceed, his jaw drops open and he is lost in a reverie that mingles with the wall-paintings in the room.

**Odysseus meets his Mother and Tiresias,
pencil on paper, 56 x 76 cm**

*The subject here is set in Hades, when Odysseus meets
his dead mother and the blind prophet Tiresias. The
drawing contains a cartoon-like bubble behind
Odysseus's head in which he is seen looking backwards
to his childhood. He simultaneously reaches forward to
touch the most naturalistically resolved part of the
drawing, which ironically is his dead mother; an image
both complete and without substance. The blinded
Tiresias witnesses the scene, and the crowd on the far
bank of the river stare back at us in recognition.*

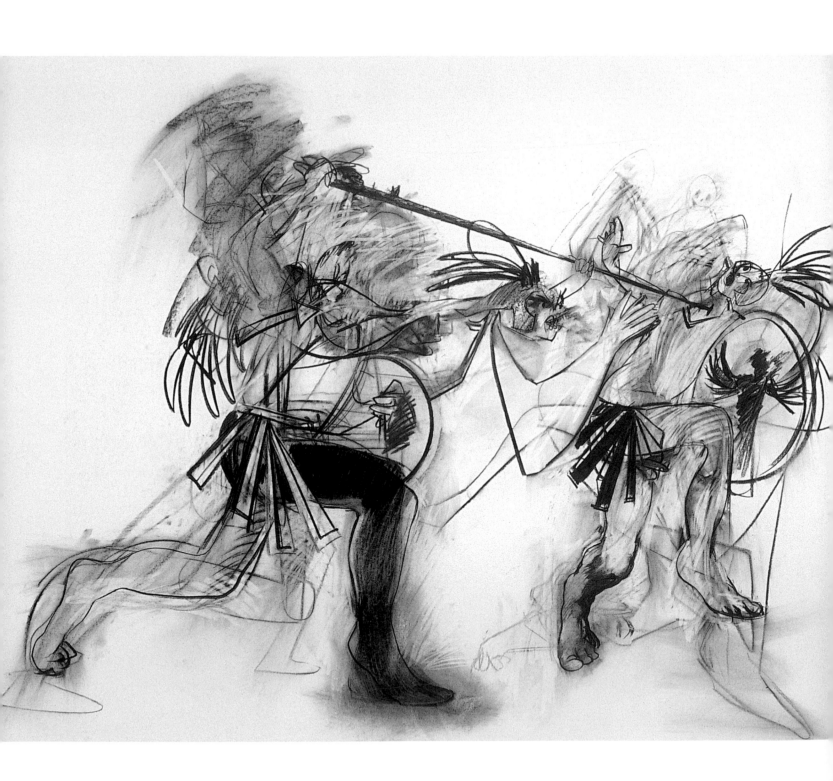

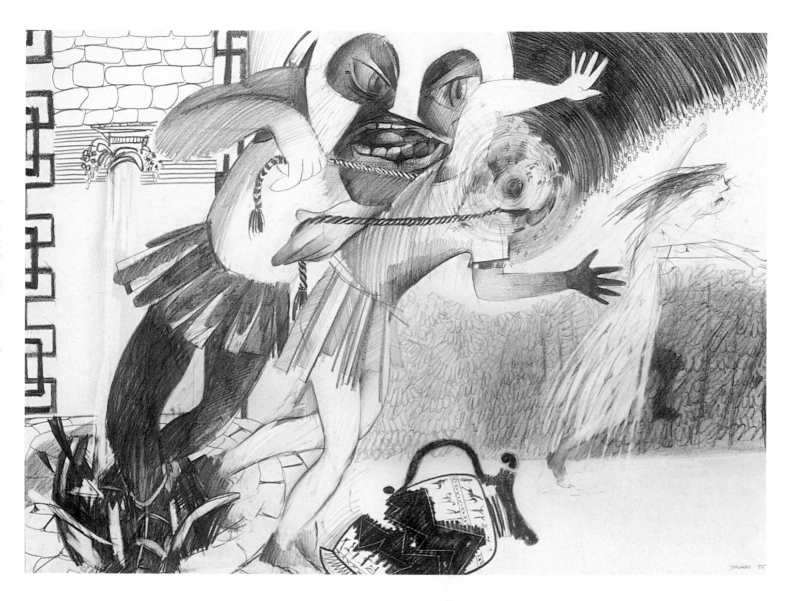

OPPOSITE: *Achilles and Hector*, charcoal on paper, 122 x 152 cm

The drawing chooses the moment when Achilles finally kills Hector after pursuing him around the walls of Troy. Only one point is exposed for Achilles to place his spear. The drawing uses the re-adjustment of Achilles's upper body to create a decisive moment of resolution; the anchoring of his leg has a major vertical, which allows the rest of the drawing to pivot on a fixed point.

ABOVE: *Achilles Surprises Troilus and Polyxena*, pencil on paper, 56 x 76 cm

Here Achilles makes a surprise attack on a young couple who had come to drink from the well. Achilles had been hiding in its damp interior. Like some monstrous toad he springs forth and ensnares the hapless Troilus with a rope around his neck. His fate had been decreed by the gods, and as he screams the formal language of the drawing wraps his anguish in a vortex of stars; the broken vessel in the foreground is a metaphor for his shattered life. Distortion is central to an understanding of the monstrous violation that Achilles has wrought on this unfortunate victim.

The Lotus-eaters, pencil on paper, 56 x 76 cm
The subject of this drawing is generally more lyrical; the openness of the line presents a lighter feel. Set against this, Odysseus's action and heaviness of tone become a real violation that disrupts the relative calm. Formally there is a link with the woman on the right whose lack of awareness of Odysseus's action allows her to be placed as a surrogate for the chicken.

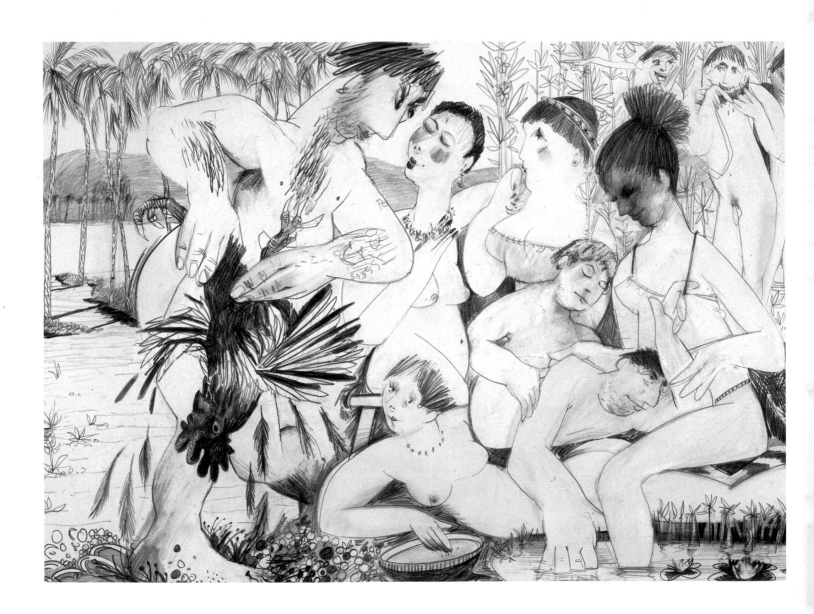

Glossary

Acetate
Transparent sheets of plastic made from cellulose acetate film, used for tracing, projecting as a transparency for transferring drawings, or as a support for drawing.

Acid-free
Term used to describe the neutral acidity of papers, indicating that the material (usually paper) will last longer and resist discoloration and deterioration.

Acrylic primer
A preparatory paint used to provide a protective and/or textured surface to paper, card or canvas.

Air-brush
A device for spraying paint using compressed air to produce a smooth mark made of minute particles of pigment.

Anamorphic
The use of accelerated perspective to depict an image which has distortion (qv), to be read from a particular viewpoint and which can be hidden within an image made with conventional perspective.

Animation
The technique of filming successive drawings to create a sequential film giving an illusion of movement; or the suggestion of movement implied within a still image.

Angle or plane of vision
The degree to which your eye level is adjusted from its normal position when looking at a subject (looking down and looking up).

Atelier system
The system of students or apprentices learning within the studio of a 'master' or senior artist.

Camera lucida
An instrument in which rays of light are reflected by a prism to produce a projected image on a piece of paper, from which a drawing can be made.

Camera obscura
A darkened box or room with a convex lens or aperture for projecting the image of an external object onto a screen, wall or support inside the box.

Cartoon
1 A drawing executed in an exaggerated style for humorous or satirical effect.

2 A full-size drawing made as a preliminary design for a painting or mural.

Centre of vision
An imaginary vertical centre line projected out from the centre of the body into space.

Chiaroscuro
The use of light and shade in drawing and painting.

Chroma
The purity or intensity of colour or hue.

Cold pressed papers
Method of manufacturing papers which results in a Not or Rough surface being formed, depending on the surface of the cylinder used to press the papers.

Collage
A method of making images with pieces or cut-out fragments of other images or materials, stuck together onto a backing piece of paper or other support.

Cone of vision
Without moving your head you have an angle of 45° of vision in all directions; this can be imagined as a cone, projected from your eye level.

Cotton linter
The fibre made from cotton plants, which forms the basis of most fine art papers.

Deckle-edge
The edges of paper made by the pressing the fibres into the mould in which it was made; as opposed to a sharp cut-edge.

Distortion
The wilful manipulation of a visual language to accommodate expression in relation to form.

Emotive mark-making
Marks in which the gesture is of prime importance.

Eye level
An imagined horizontal plane projected from the level of your eyes, which is the level at which you view the world.

Field
In relation to an image, the 'field' is the area which surrounds a form or shape. In the absence of a formal shape, the field predominates. The field defines the space within which the object or subject is visible or located.

Fixative
An acrylic resin and lacquer thinner used to 'fix' an image made of dry materials such as pastel or charcoal.

Fixed-point perspective
An artificial system for creating three-dimensional space which assumes that you work from a fixed viewpoint. The consequent disappearing perspective means that the lines seem to converge to a single point.

Floor-plane
The surface or plane on which the objects or subjects sit in space.

Form
Form in relation to shape has the potential to make a three-dimensional presence. A shape exists in two dimensions and a form has the potential to suggest it exists in three dimensions.

Format
The way in which a drawing is arranged or presented, for instance in a horizontal format known as a landscape format, or a vertical format known as a portrait format.

Fugitive
A property which means the pigment or coloration will not remain constant over a period of time (eg fugitive colours), and that the image will change because of the properties of the pigment.

Glassine
A glossy transparent paper, used to protect the surfaces of artworks.

Golden section
The division of a line so that the whole is to the greater part as that part is to the smaller part; a proportion which is considered to be particularly pleasing to the eye.

Ground
The prepared surface to which paint or other drawing materials are applied, and which may be used to supply a particular colour, texture or medium on which to make the overall drawing.

Haptic distortion
Distortion for emotional emphasis.

Hot pressed
Method of preparing the surface of paper in manufacture using hot cylinders to press the papers resulting in a smooth surface. Sometimes abbreviated to HP.

Hue
The term for a colour or family of colours.

Key
The chosen range of tone or value used within an image, eg half-tone, full contrast, etc.

Lay figure
A jointed mannequin of a human body used by artists as a substitute for a model, available life-size and in miniaturised versions.

Life Room
A studio dedicated to the drawing, painting or modelling from the life model, a person who models for an artist.

Lightfastness
Permanence of a material, unaffected by the effects of light which can bleach or change the colour of pigments which are not lightfast.

MDF
Medium Density Fibreboard; a manufactured board made from compressed sawdust which forms a stable support on which to work, once prepared with a suitable surface, eg gesso.

Mouse
A dry cleaning pad, a stockinette pouch containing minute particles of rubber used to clean up drawings.

Perspective
A he representation of three-dimensional objects on a two-dimensional surface to convey the impression of height, width, depth and relative distance.

Point relationships
The relationship of selected points of measurement within an objective drawing made from life.

Props
Objects used in the setting up of a still-life or model.

Saturation
The purest intensity, or highest chroma, of a colour or hue, without any addition of another colour, white or black.

Scale
A he relative size of one element to another.

Size
A glue-like sealant, either applied to a surface or support or incorporated into the manufacturing process of paper (internally-sized) to resist the full absorbency of materials into the fibres of the support.

Spatial relationships
The relationship of forms or objects in space, as opposed to the space between objects on a surface. The relationship of – 'space between' and 'implied space behind' – objects is a fundamental principle in drawing.

Squaring up
The technique of transferring a drawing to another support by drawing squares over the original design and copying the information, square by square, to another support.

Storyboard
A sequence of drawings representing the shots planned for a film or animation, and which identify the sequential unfolding of the plot.

Support
The structure employed to support the work of art, eg paper, canvas or board.

Tint
T tint is a colour which has had white added to it; as opposed to 'shade', which is a colour which has had black added to it.

Tonal scale
The scale of lightness to darkness, from black (darkest) to white (lightest).

Tone
The description of the modulation of light and dark across a surface.

Value
The lightness and darkness of a hue or colour, which is described as tone in a black-and-white image.

Bibliography

Arnheim, R, *Picasso's Guernica*, Faber and Faber Ltd, London, 1962.

Ashton, D, *Documents of Twentieth Century Art: Picasso on Art*, Thames and Hudson, London, 1972.

Baxandall, M, *Shadows and Enlightenment*, Yale University Press, New Haven & London, 1995, 1997.

Berger, J, *Keeping a Rendezvous*, Granta, London, 1992.

Berger, J, *Ways of Seeing*, BBC & Penguin, London, 1972.

Bouleau, C, *The Painter's Secret Geometry*, Harcourt, Brace & World, Inc, New York, 1963.

Chipp, H B, *Theories of Modern Art*, University of California Press, 1968.

Cirlot, J E, *A Dictionary of Symbols*, Routledge & Kegan Paul Ltd, London, 1967, reprinted 1983.

De Francia, P, *Fernand Léger*, Yale University Press, 1983.

Derrida, J, *Memoirs of the Blind, The Self-Portrait and Other Ruins*, University of Chicago, 1993; originally published as *Mémoires d'aveugle: L'autoportrait et autres ruines*, Editions de la Réunion des Musées Nationales, 1990.

Didi-Huberman, During & Poggesi, *Encyclopaedia Anatomica, A Complete Collection of Anatomical Waxes*, Museo La Specola, Florence, Taschen, 1999.

Flam, J D, *Matisse on Art*, Phaidon, Oxford, 1973.

Glimcher, A & Glimcher, M, *Je suis le cahiers, The Sketchbooks of Picasso*, Thames and Hudson Ltd, London, 1986.

Graves, R, *The Greek Myths*, Penguin, London, 1955, 1960.

Gregory, R L, *The Intelligent Eye*, McGraw-Hill, New York, 1970.

Harrison, Wood & Gaiger, *Art in Theory 1648-1815*, Blackwell, Oxford, 2000.

Holt, M, *Mathematics in Art*, Studio Vista, London, 1971.

Kemp, M & Wallace, M, *Spectacular Bodies*, Hayward Gallery, London & University of California, 2000.

Kendall, R, *Cézanne by Himself*, Macdonald & Co, London, 2003.

Kingston, A, *What is Drawing?*, Black Dog Publishing, London & The Centre for Drawing, Wimbledon School of Art, London, 2003.

Mayer, R, *The Artist's Handbook of Materials and Techniques*, Faber and Faber, London, 1951, republished 1981.

MacCurdy, E, *The Notebooks of Leonardo da Vinci*, Jonathan Cape, London, 1938.

McGrath, S, *Brett Whiteley*, Bay Books, Sydney, 1979.

Pearce, E, *Artists' Materials: Which, Why and How*, A & C Black, London, 1992.

Petherbridge, D, *The Primacy of Drawing*, South Bank Centre, London, 1991.

Petherbridge, D, *The Quick and the Dead, Artists and Anatomy*, South Bank Centre, London, 1997.

Rawson P, *Drawing*, Oxford University Press, 1969.

Rawson P, *Seeing through Drawing*, BBC Publications, London, 1979.

Rose, B, *Allegories of Modernism, Contemporary Drawing*, Museum of Modern Art, New York, 1992.

Ruskin J, *The Elements of Drawing*, 1859; ed 1991, Herbert Press, UK.

Simblet, S, *Anatomy for the Artist*, Dorling Kindersley, London, 2001.

Wadley, N, *Impressionist and Post-Impressionist Drawing*, Laurence King Ltd, London, 1991.

The Jerwood Drawing Prize exhibition catalogues (formerly the Cheltenham Open Drawing Exhibition)
1997, essay by Nick Tite; 1998, essay by David Alston.
1999, essay by Alexander Moffat.
2000, essays by selection panel: Andrew Brighton, Mel Gooding, Isobel Johnstone, Doris Lockhart Saatchi.
2001, essays by selection panel: Frances Carey, Richard Cork, Angela Kingston.
2002, essays by selection panel: Marco Livingstone, Cornelia Parker, Marina Warner.
2003, essays by selection panel: Ken Currie, William Feaver, Anita Taylor.
website: http://www.jerwood@wimbledon.ac.uk

ACKNOWLEDGEMENTS

The authors wish to thank the following artists for their permission to reproduce their work on the listed pages in this book: Andrew Bick (Pearson Collection, London), 54; Cheryl Brooks, 70; David Connearn, 41; Adam Dant, 46; Gerald Davies, 42; Robert Davison, 52; Katayoun Pasban Dowlatshahi, 67; Peter de Francia, 14; Milda Gudelyte, 51; Claude Heath, 71; Estate of Judy Inglis, 43, 55; Jen-Wei Kuo, 47; Aled Lewis, 36; Paul Mason, 37; Amanda Nash,106; Annie Phelps, 49, 104, 107; Paul Rosenbloom, 97; James Rowley, 12; Paul Ryan (Collection: Imperial War Museum, London), 15; Deborah Sears, 38,39; Varvara Shavrova, 59; Michael Shaw, 71 Sarah Simblet, 29; Emma Talbot, 63; Chris Thomas, 27, 112; Kim Williams, 2, 13, 86, 87, 88, 89, 90, 91, 92, 93, 94, 95; Wimbledon School of Art (design by Zoe Dorelli/ Mike Gough), 18; Sarah Woodfine, 58; Dan Young, 68, 69; and thanks to the Bridgeman Art Library for the images reproduced on pages: 26, 32, 34, 35, 98.

Special thanks are also due to Tam Inglis; Stewart Whittall; Kim Williams; former students of Cheltenham School of Fine Art, University of Gloucestershire; Karen Bateson, the Jerwood Drawing Prize archive; Wimbledon School of Art.

Index

Page numbers in *italic* type refer to picture captions.